The College History Series

MONMOUTH
UNIVERSITY

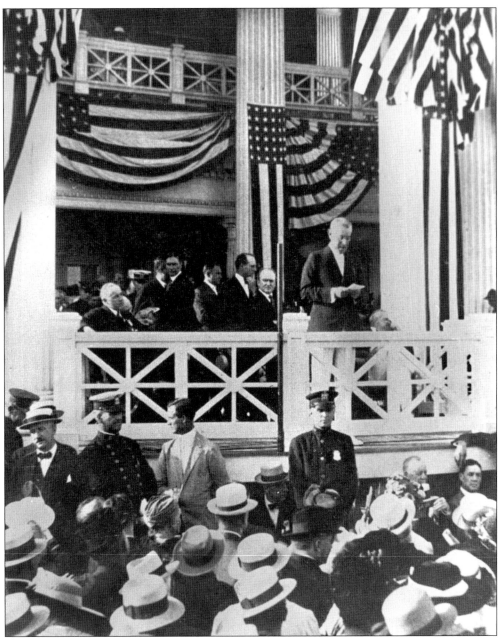

Pres. Woodrow Wilson speaks from the "Summer Capital of the U.S.A." (as Shadow Lawn was dubbed) on Notification Day, September 2, 1916. On that day, Wilson officially accepted the notice of his reelection in front of thousands of spectators at the beautiful estate that is now Monmouth University in West Long Branch, New Jersey.

The College History Series

MONMOUTH
UNIVERSITY

JIM REME AND TOVA NAVARRA

ARCADIA

Published by Arcadia Publishing,
an imprint of Tempus Publishing, Inc.
2A Cumberland Street
Charleston, SC 29401

Printed in Great Britain.

Library of Congress Catalog Card Number: 2002100072

For all general information contact Arcadia Publishing at:
Telephone 843-853-2070
Fax 843-853-0044
E-Mail sales@arcadiapublishing.com

For customer service and orders:
Toll-Free 1-888-313-2665

Visit us on the internet at http://www.arcadiapublishing.com

This book is dedicated with lots of love to Andrew James Reger (left) from "Pop-Pop" and to Vincent Paul Fleming from "Nonni." *Tante belle cose, i nostri due piccoli angeli!* (Photographs by Jim Reme.)

CONTENTS

ACKNOWLEDGMENTS

We are very grateful for the support of Dr. Rebecca Stafford, President of Monmouth University, and Janet Fell, her administrative assistant; Susan Doctorian, Associate Vice President for Public Affairs; Marilyn W. Perry, Director of Alumni Affairs, and the staff of Alumni Affairs; Dennis C. Macro, Vice President of Institutional Advancement; Paul Corliss of the Monmouth University Board of Trustees; the late Robert F. Van Benthuysen, author of *Crossroads Mansions: Shadow Lawn and the Guggenheim Cottage* (Turtle Mill Press, 1987); the Guggenheim Library archival collection; Deanna Scherrer (Class of 1989), assistant to the Vice President of Administrative Services; Kay Zimmerer; and Liz Clark and Dan Weeks, former Assistant Directors of University Communications. Many thanks go to Amy Sutton, Jill Anderson, and the staff at Arcadia Publishing and to Ralph Binder for the numerous photographs he shot between the 1960s and the early 1990s, when he was the university photographer. We also thank our families for their support: Gina, Drew, and Andrew Reger; Matt and Alison Schmidt; Jamie, Lauren, and Lindsey Reme; Yolanda, Guy, Amanda, Wesley, and Vincent Fleming; Johnny and Mitzi Navarra; and Ed Dalton (Class of 1971).

Last but not least, we must admit to our special sentiment for Wilson Hall, where we met on May 18, 2001.

—Jim Reme and Tova Navarra

INTRODUCTION

Daddy Warbucks brought Little Orphan Annie into a splendor nothing short of Monmouth University's Wilson Hall, which cost $10.5 million to build as a private residence in 1929. By 1981, when the movie *Annie* was filmed at the university, the jewel of the campus had already served as the McCall and Parson homes, as the summer White House, and as a private high school for girls. There were times, however, when the original Shadow Lawn mansion seemed like an architectural child in dire straits—it suffered destruction by fire, endured an arduous rebuilding, and long teetered at the brink of financial ruin. Its decline was so severe that it was eventually sold at a public auction for a mere $100. Despite these troubles, the magnificent property evolved into a respected Jersey Shore university, located in West Long Branch. Monmouth College, formerly a junior college, bought the property in 1956 and developed the small school into a modern learning institution that now boasts extensive undergraduate and graduate programs. Dignitaries and celebrities visit, and grateful alumni and prominent friends donate major sums toward the university's enhancement. In addition, Monmouth University serves as an abundant source of art, music, theater, dance, and literature in the region.

That the history of Monmouth University started with riches instead of rags may be interpreted as having boded well for the future. Historian Robert F. Van Benthuysen recounted that on July 12, 1902, John A. McCall (president of the New York Life Insurance Company), who summered in Allenhurst, purchased the Hulick farm on Cedar and Norwood Avenues, the present site of Monmouth University. The deal included a farmhouse and 27 acres of land. McCall also bought contiguous acreage from Mrs. Charles Abbott and Mrs. Ettie Henderson. The insurance magnate then hired architect Henry Edward Cregier to fashion a villa reminiscent of the Alhambra, the Petit Trianon, and San Souci in France. In August 1903, McCall moved into the 52-room "modified Colonial" frame house with gold-plated plumbing, promenades, porches, fireplaces, and seemingly endless glories on a grassy knoll. Two years later, at the same time that Murry and Leonie Guggenheim occupied the mansion on the other side of Cedar Avenue (the splendid home that was to become Monmouth University's library), McCall admitted under fire of public investigation that he bribed legislators to the tune of $275,000.

McCall was forced to resign from the New York Life Insurance Company, and he sold the estate called Shadow Lawn to Myron T. Oppenheim, a New York City lawyer, for $350,000. Oppenheim wanted to turn the estate into the Brook Lawn Country Club for 500 members at $2,000 per membership, but plans fizzled. Five months after McCall died in a Lakewood hotel on February 18, 1906, Oppenheim sold Shadow Lawn to Abraham White, president of the DeForest Wireless Telegraph Company, for $500,000. White renamed the estate White Park, but his time there was short. The poor boy from Texas who hit it big on Wall Street failed to pay the original mortgage of $100,000 given by John McCall in 1903, and the Abraham White Realty and Improvement Corporation was foreclosed in 1908.

Desirous of protecting his second and third mortgages, Oppenheim reappeared at the sheriff's sale of the property and for $125,000 turned it over to Robert L. Smith, who briefly reinvented

the Brook Lawn Country Club. Stability eluded Shadow Lawn until Joseph Benedict Greenhut acquired it in 1909 and lived in it for nine years. The principal partner in the Siegel, Cooper Company (the earliest of huge department stores in Manhattan), Greenhut easily paid $200,000 for the property. He also spent about $400,000 renovating and landscaping it. Enter Pres. Woodrow Wilson, who was invited to use Shadow Lawn as a summer home in 1916 by Greenhut, Congressman Thomas J. Scully of Deal, and other state dignitaries.

At Shadow Lawn, where people flocked by the thousands to see its illustrious tenant, Wilson learned of his reelection. After he returned to Washington, D.C., Wilson never went back to the estate that was soon to become the home of Hubert Templeton Parson, vice president and general manager of the F.W. Woolworth Company, and his wife, Maysie Gasque Parson. The Parsons, along with Maysie's mother and sister, occupied Shadow Lawn from 1918 until 1936 (the mansion had been destroyed by fire and rebuilt during this period), when the Great Depression brought Parson to financial demise. He owed huge amounts of money at the very time he turned 60 (the mandatory retirement age), and his stint at Woolworth crumbled.

By 1939, what had been the summer White House was on the auction block. It sold for $100 to West Long Branch borough, which clamored for potential buyers. Shortly before Parson's death, Maysie paid $32,592 in property taxes to the borough. This payment earned her the right to sell the contents of the mansion as she wished. Meanwhile, several entrepreneurs expressed interest in leasing or buying the property, but it was in 1942 when the borough sold the estate for $100,000 to Eugene H. Lehman, director of the Highland Manor School for girls in Tarrytown-on-Hudson, New York.

Lehman, who was to become the first president of Monmouth College, moved his students to West Long Branch and ran the Highland school for the next 14 years. Interestingly, in January 1946, representatives of the United Nations were searching for a permanent home for the organization and took a liking to the house and grounds of Highland Manor, once attended by actress Lauren Bacall. However, a gift of $8.5 million from John D. Rockefeller Jr. turned the attention of the United Nations to a tract in Manhattan, where its headquarters was built in 1948. In a historical vignette in the December 17, 2001 *Asbury Park Press,* Arthur E. Scott wrote, "Motorists struggling to negotiate the intersection of Norwood and Cedar avenues . . . should reflect that things could have been far worse. Instead of becoming Monmouth University . . . that corner might have become the 'capital of the world.'"

In 1955, Lehman sold the estate to Monmouth Junior College, which was then operating after 4:00 p.m. in Long Branch Senior High School. The college opened its new doors in 1956, one of the first baby steps toward a sophisticated dream. "University is the name that fits, the name that clarifies what we are, our institution as it exists today," said Pres. Rebecca Stafford in 1995, the year Monmouth received official designation as a university. Everyone, it seemed, shared unbridled enthusiasm for the "birthday" of Monmouth University.

In a special March 24, 1995 edition of the *Outlook,* the student-run newspaper since 1933, Dr. Thomas Pearson (now provost and vice president for academic affairs) said, "I feel Monmouth has been in fact a teaching university for the past decade or so, and its designation as such is a tribute to the fine work and leadership of its faculty, staff and administrators, past and present. We have much to look forward to in the coming years as we achieve regional distinction . . . and serve as a model to other higher education institutions." Dr. Prescott Evarts, then chairman of the Department of English and Foreign Languages, told the *Outlook* that university status would pick up the intellectual tone of the school. Patricia Swannack, vice president for administrative services, added that the designation was long overdue and everyone should be proud. Women's basketball coach Susan DeKalb said, "I think it will help tremendously going into homes out-of-state that have never heard of us. Monmouth University will give us an edge."

Perhaps the *Outlook*'s editorial summed it up best: "For so long, Monmouth College did all the right things to help itself earn university status." In this book are highlights of many of those right things—a history of efforts and values that took a mansion and turned it into a unique world of infinite possibilities.

One

"SHADOWS ON THE LAWN"

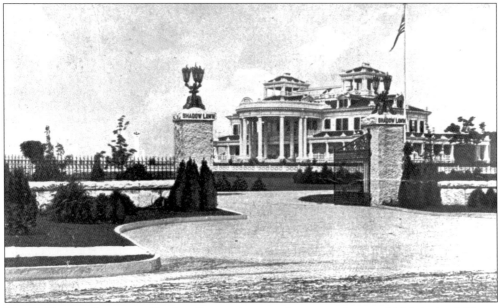

The idyllic-sounding name Shadow Lawn, given to the estate that would birth the 148-acre campus that is now Monmouth University, evolved from "clusters of great trees planted in the English naturalistic park tradition on the vast lawn," as James T. Maher wrote in *The Twilight of Splendor: Chronicles of the Age of American Palaces* (Little, Brown and Company, 1975). Maher added that a widely quoted poem written in 1916 by Theodore Roosevelt to criticize Pres. Woodrow Wilson, who was then seeking reelection, began with the line, "There are shadows on the lawn at Shadow Lawn." Roosevelt meant the tragic "shadows" of Americans who died as a result of the nation's immediate entry into World War I. Despite such a daunting image, Shadow Lawn was among the most famous private homes in the country, in part because it was mentioned in many news stories covering Wilson's campaign.

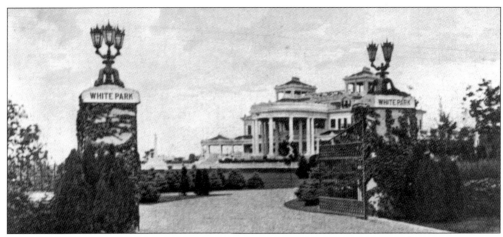

John McCall, president of the New York Life Insurance Company, purchased the 27-acre Hulick farm and two other contiguous plots of land on Cedar and Norwood Avenues and built Shadow Lawn in 1902 and 1903. Designed by architect Henry Edward Cregier, the white wooden modified Colonial had two stories, 52 rooms, and gold-plated plumbing. In 1905, McCall was forced to resign after he was caught spending $275,000 on bribes to legislators on behalf of the company. New York City lawyer Myron T. Oppenheim bought the estate at $350,000 for a client on January 24, 1906, with the intention of creating a country club, but he could not attract enough members. Five months after McCall died a pauper at the Laurel Hotel in Lakewood, Oppenheim sold the estate to Abraham White, of Corsicana, Texas, president of the DeForest Wireless Telegraph Company.

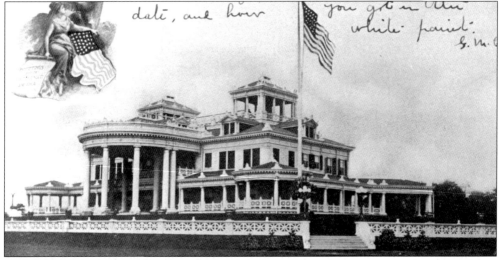

One of the most colorful characters ever connected to Shadow Lawn, Abraham White paid $500,000 for it—money he made from bullying Union Pacific stock during one Friday's lunch. White changed the name Shadow Lawn to White Park and went on to make a fortune in business. His success was short-lived, however. The Abraham White Realty and Improvement Corporation was foreclosed on June 19, 1908, for failure to pay McCall's original mortgage of $100,000. After White's stint as owner of the estate, Oppenheim stepped in and mortgaged it for $125,000 to Robert L. Smith in July 1908, who converted it into the Brook Lawn Country Club. Joseph Benedict Greenhut, principal partner in the Siegel, Cooper Company department store in New York City, bought it in April 1909 for $200,000.

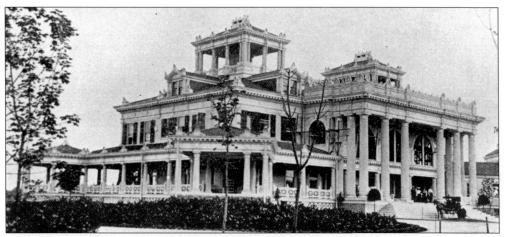

A man of great means, Joseph Benedict Greenhut renamed the estate Shadow Lawn and lived there for nine years. He hired Duncan Kelley as a professional superintendent, spent $400,000 renovating the house and grounds, and eventually, along with Congressman Thomas J. Scully of Deal and other state dignitaries, invited Pres. Woodrow Wilson to summer there in 1916. Wilson accepted. This rear view of the original Shadow Lawn features its imposing entrance and a glimpse of the surrounding gardens.

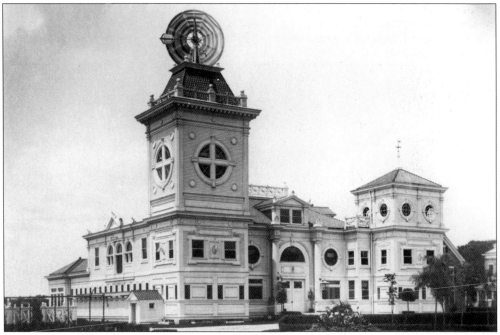

Today, the 800 building on campus houses the 800 Gallery, art classrooms and studios, and the Rotary Ice House Gallery. This, the original stable and carriage house, had a giant water tower and windmill. According to Robert F. Van Benthuysen's booklet *Crossroads Mansions: Shadow Lawn and the Guggenheim Cottage,* water was drawn from an artificial lake created by damming Whale Pond Brook on the southern boundary of the estate. Ice that was cut from the lake was kept in the icehouse, which was restored by virtue of money raised by the Long Branch Rotary Club. Adjoining the main building were a tool house, children's playhouse, cottages, a gate lodge, and flower and vegetable gardens.

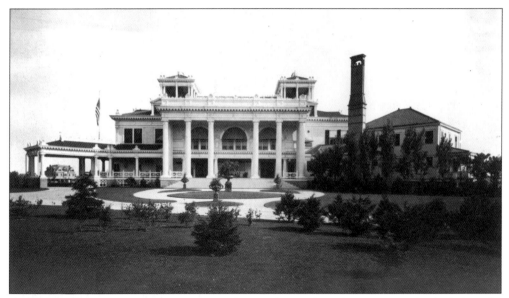

The first Shadow Lawn, once criticized as "all vocabulary and no rhetoric," was also hailed as "the Versailles of America." The palace in Versailles was a veritable playpen for King Louis XIV of France, who endlessly entertained nobles, visiting royalty, ambassadors, and all manner of artists and musicians.

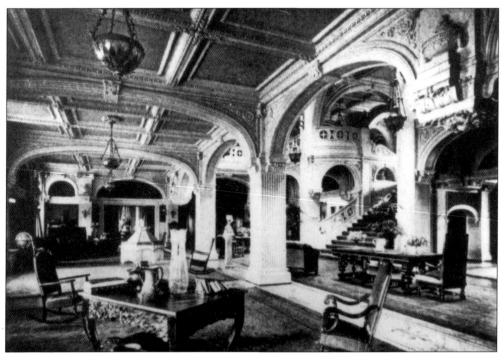

Shadow Lawn's social hall, or cortile, had been richly furnished by John McCall, the original builder and owner of the mansion. McCall ended up on his deathbed with a cancer accelerated, some say, by the insurance company scandal that forced him to resign his job and lose Shadow Lawn.

In another view of McCall's
summer palace, one can see that
its 52 or 53 rooms "ranged
around an axial (east-west) cortile
that rose through the house to a
roof skylight," as James Maher
wrote. "Huge dormer windows
with Greek temple pediments
surmounted by acroteria, plinths
holding small statues of griffons,
broke the slope of the attic roofs.
Long spans of pierced parapet-
railings (authentically Roman. . .)
framed its spacious colonnade-
verandas, which bulged into
circular belvederes (small
temples) at the corners of
the house."

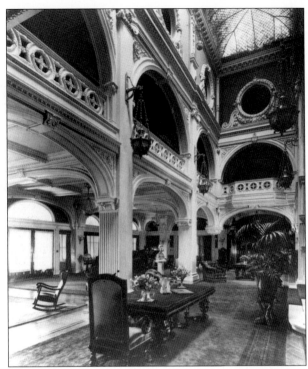

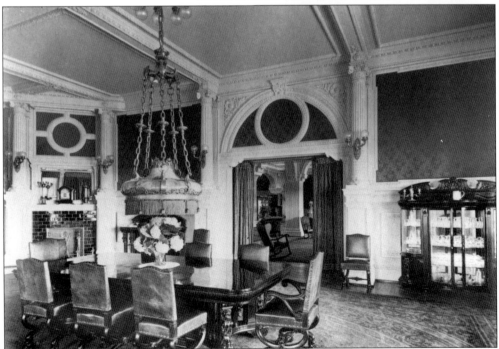

Maher recounted that McCall most likely engaged William Baumgarten & Company of New York
to decorate Shadow Lawn, particularly because that was the opinion of James F. Durnell, a Long
Branch native and New York City real estate man who was "an encyclopedic archivist of the Jersey
Shore." At the time, Baumgarten's was one of the three leading decorating firms in the city.

13

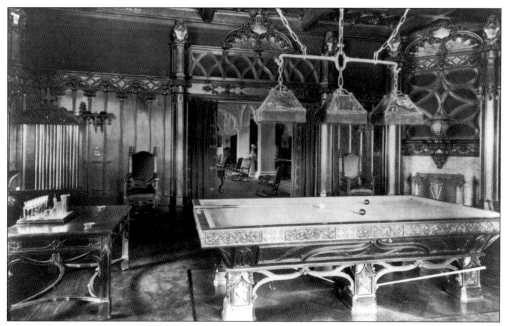

This architecturally detailed billiard room was located on the first floor of the original Shadow Lawn mansion.

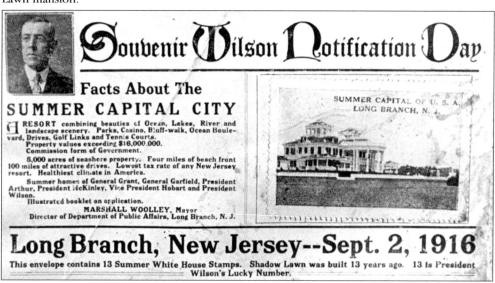

In 1916, the *Long Branch Record* printed this story touting Long Branch and the "Summer Capital of the U.S.A."—so named because of the presidents who visited the Long Branch area, including Ulysses S. Grant, James Garfield, Chester A. Arthur, and Woodrow Wilson. A series of summer White House stamps were issued as souvenirs of Notification Day. Wilson and his entourage arrived the night before to a power failure that left Shadow Lawn in the dark for about half an hour while repairs were made. In her *Memoirs,* Wilson's second wife, Edith, described Shadow Lawn as looking like a large summer hotel, "very large, with a staircase, wide enough for an army abreast, opposite the front door. This staircase ended in a big platform on which rested a grand piano. Then the stairs parted to run in opposite directions as if each was ashamed of the other. . . . When we got settled, we were happy and comfortable at Shadow Lawn."

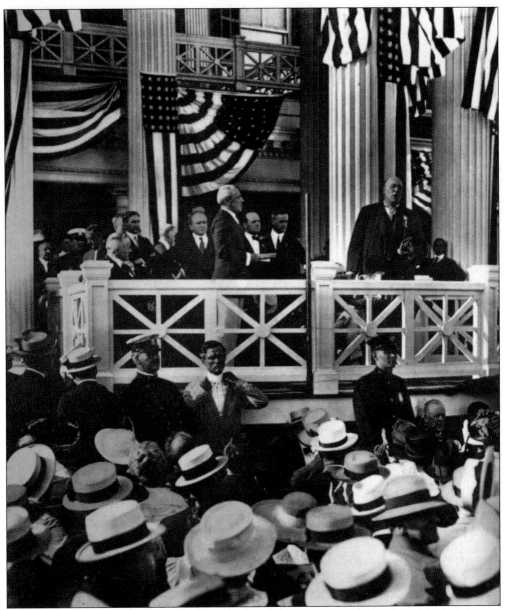

Draped with the Stars and Stripes, Shadow Lawn served as Notification Day's site, where Sen. Ollie James of Kentucky made the notification speech (announcing Pres. Woodrow Wilson's nomination for a second term) and presented Wilson to the crowd. Wilson, former president of Princeton University and governor of New Jersey, accepted the nomination and went on to win a Nobel Peace Prize for his establishment of the League of Nations.

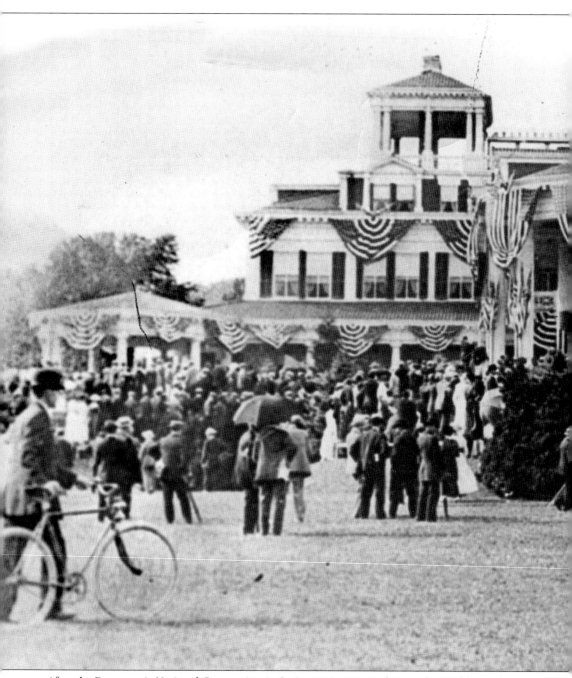

After the Democratic National Convention in St. Louis, Pres. Woodrow Wilson addressed 15,000 to 20,000 people who gathered at Shadow Lawn at 10:00 a.m. on September 2, 1916. Guests included Vice Pres. Thomas Riley Marshall, cabinet officers, members of Congress, other prominent Democrats, and the president's family. A buffet luncheon before the ceremony entertained members of the Notification and Democratic National Committees and the Mexican

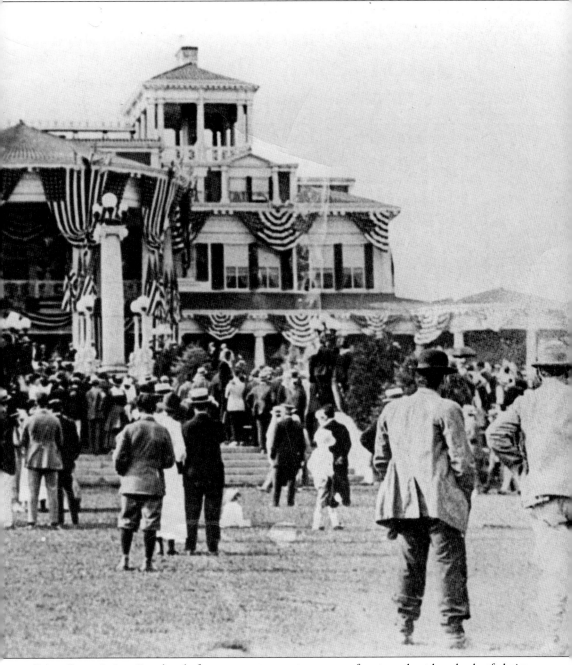

Peace Commission. For days before, carpenters put up rows of seats and set hundreds of chairs facing the house, and a speaker's stand was added to the porch. Throughout the town, banners directed spectators to Shadow Lawn. Policemen came in from Newark and Asbury Park to bolster Long Branch security. It is reported that Wilson insisted on donating $2,500 to Monmouth County charities in lieu of rent for the use of Shadow Lawn as the summer White House.

SHADOW LAWN, HOME OF HUBERT T. PARSON, IS TOTALLY DESTROYED

Mansion, In Summer of 1916 Occupied By Late President Wilson, and Long One of Best Known Show Places of Jersey Coast, Razed In $2,000,000 Fire Last Night---Art Treasures, Costly Tapestries, Rugs and Furniture Go Up In Smoke---Place Today Is Heap of Smouldering Ruins

CONFLAGRATION SEEN FOR MILES AROUND

Original Owner of Beautiful Country Residence
Was John A. McCall, One Time President
of New York Insurance Company---
Blaze, Believed To Have Been
Caused By Defective Wiring,
One of Most Spectacular
Ever Seen Here

These headlines appeared in the local newspaper, the *Long Branch Record*, and no doubt brought a wave of sadness to the public for the place where Pres. Woodrow Wilson spoke on numerous occasions during his "front-porch" campaign for reelection. After his reelection, Wilson would never return to Shadow Lawn. A southerner by birth who seemed to be well-contained, refined and quiet by nature, Wilson will always be remembered as an exceptional orator, intellectual and intensely passionate in matters of both politics and the heart.

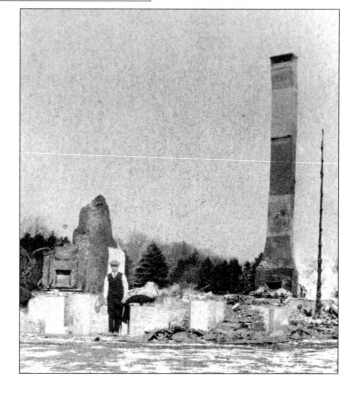

John Pocaro, an employee of then Shadow Lawn owner Hubert Templeton Parson, stands among the ruins of Shadow Lawn. They would soon be the sight of the magnificent mansion that still stands as the foremost pride and joy of the Monmouth University campus. Parson would be the last private owner of Shadow Lawn.

Two

THE PARSONS AND THE
GUGGENHEIMS COME TO TOWN

Toronto-born Hubert Templeton Parson bought Shadow Lawn from the Harsen-Langham Corporation in June 1918. On November 17 of that year, Joseph B. Greenhut (also called Captain Greenhut) died. Greenhut's real estate firm, Monmouth Securities, had transferred the property to the corporation. According to title records, the corporation sold it to Parson for $800,000, and Parson gave them a purchase money mortgage of $150,000. On March 16, 1918, Greenhut's son, Benedict J. Greenhut, announced that the Big Store in Manhattan would be closing and the building would be rented as loftspace to a manufacturer of uniforms.

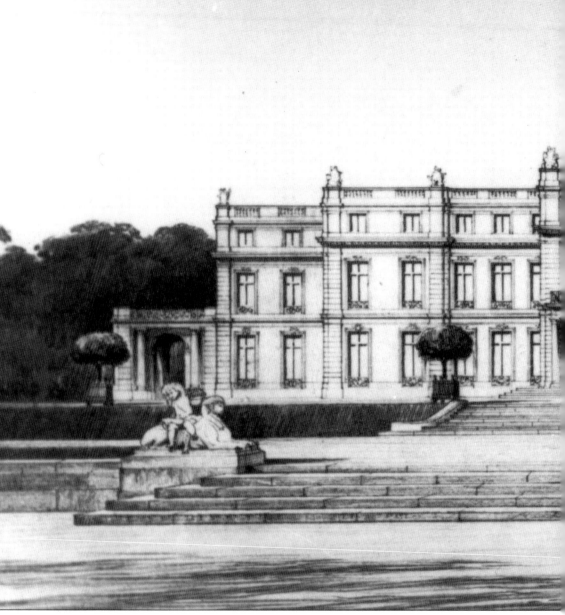

Architect Horace Trumbauer's rendering of the Shadow Lawn mansion that would be built by Hubert Templeton Parson includes sphinxes and *amorini* modeled after the ones at

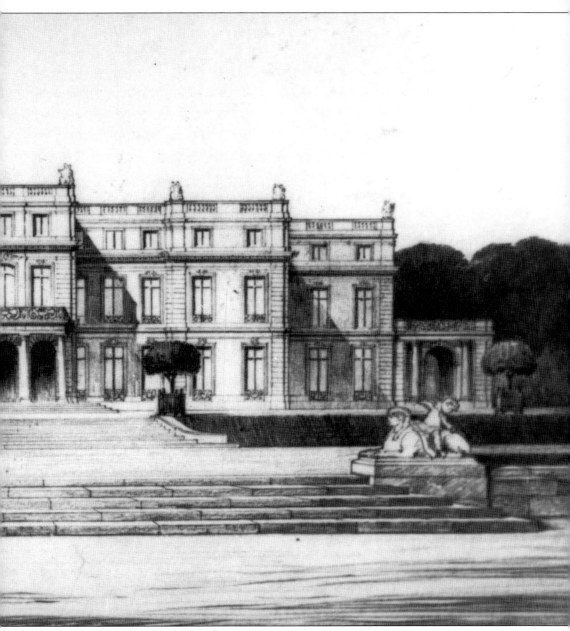

the palace of Versailles.

Some of the workmen who built Shadow Lawn were European craftsmen. For Hubert Templeton Parson, a man described as a brilliant financier but self-centered, strict, and strangely unsociable, Shadow Lawn was to reflect the extravagant lifestyle preferred by him and his wife, Maysie Gasque Parson, who was born in Bayonne. They married in 1893, both at 21 years of age. James T. Maher accounts that Parson's employer, F.W. Woolworth, very likely provided the money for the acquisition of the Shadow Lawn property in his will. He died in 1919. Parson had been appointed Woolworth's legal guardian during the old man's later years and, along with Woolworth's two surviving daughters, served as executor of his estate.

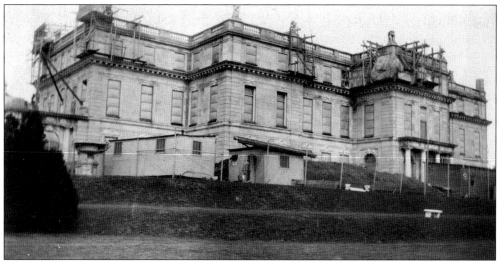

Always in fierce competition with F.W. Woolworth's penchant for building, F.W. Woolworth company president Hubert Templeton Parson hired Philadelphia architect Horace Trumbauer and his assistant, Julian F. Abele, to design the new Shadow Lawn in June 1918. The chief designer and draftsman in the Trumbauer firm, Abele was one of the few African American architects at the time. After Trumbauer died in 1938, Abele continued his work at the firm. Abele created Parson's mansion, shown here under construction, in a neoclassical French tradition that incorporated Indiana limestone, steel, concrete, and 50 varieties of Italian marble to make it fireproof.

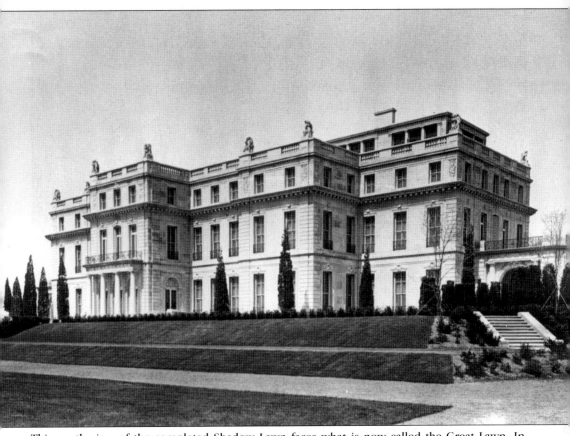

This south view of the completed Shadow Lawn faces what is now called the Great Lawn. In October 1920, Parson hired George W. Thomson as superintendent of the estate and grounds. Thomson came from a long line of Scottish gardeners and served for 13 years at Shadow Lawn, managing a staff of 40 groundskeepers. In April 1978, the building was entered into the National Register of Historic Places as Woodrow Wilson Hall.

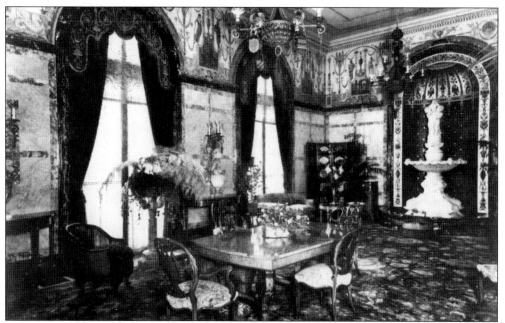

The Parsons' conservatory and breakfast room on the first floor features access to the gardens, which were designed in Paris by renowned landscape architect Achille Duchene. Today it is known as the Pompeii Room in Wilson Hall.

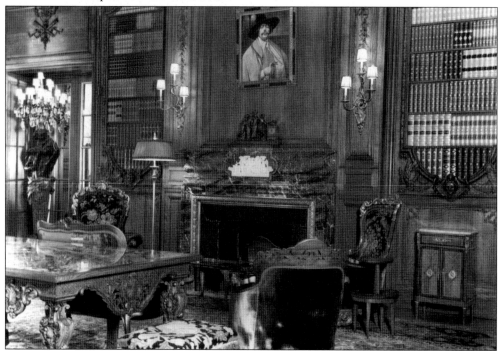

The Parsons' library, also on the first floor, was a replica of the Hoenschel Parisian Study, in which false book fronts (made from the bindings of duplicate volumes) were installed so the actual book collection could be hidden behind them. This room now serves as one of the rooms of the university's admissions office at the east end of the Great Hall.

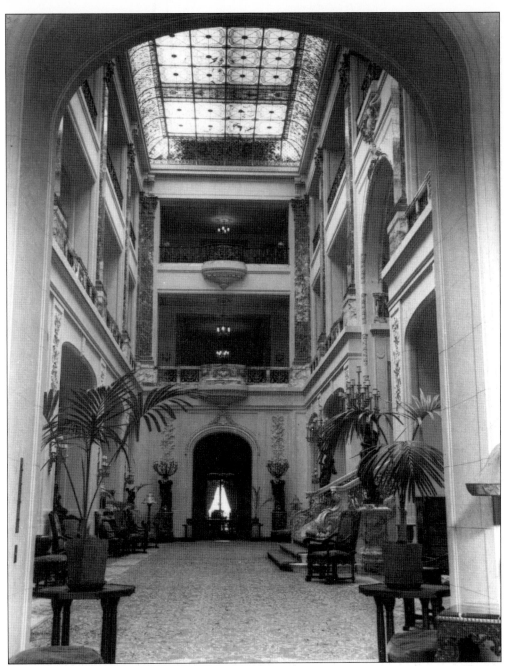

The Great Hall in the center of the mansion measures 25 by 110 feet and rises nearly 70 feet to the Venetian stained-glass skylight, where motifs include leaves, vines and other icons of several ancient cultures. At night, the 100-foot skylight can be illuminated by 165 lights. Hubert and Maysie Parson and Maysie's sister (who also lived in the mansion) were attended by more than 100 servants. At each end of the Great Hall are elevators and fireplaces. In addition to the unbridled extravagances throughout Shadow Lawn, Hubert could not deny Maysie's wish for a rooftop solarium, which upon its completion in 1930, cost more than $500,000 alone. The cost of running the mansion was already at least $300,000 a year, much of that for heating.

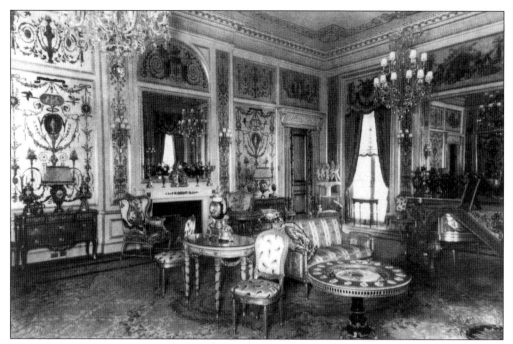

The first-floor music room's intricately patterned designs are of the Marie Antoinette period. The grand piano to the extreme right appears to have a gilded finish that was protected by a large piano scarf. The university's financial aid office now occupies this room.

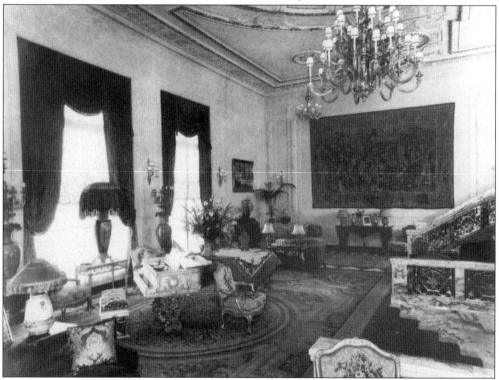

A grand piano graces the music mezzanine at the top of the Great Hall's central staircase.

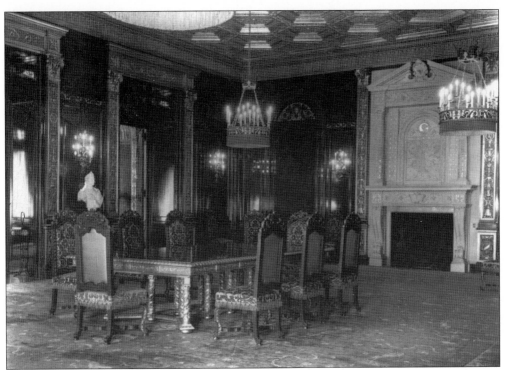

The Versailles Room, the formal dining room, is now used for meetings and parties.

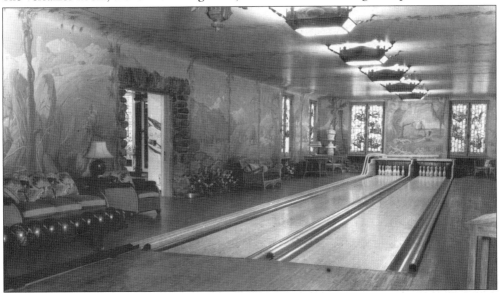

Originally, the lower level of the mansion boasted an auditorium with a large movie screen, a fireproof projection room with two Paramount projectors mounted in tandem to provide continuous showings, a stage with floodlights and footlights, and a puppet theater set along the wall opposite the entrance. Also on the lower level near the auditorium was a two-lane Brunswick bowling alley, in which murals and stained-glass windows depicted the life of prehistoric man. While excavating for the lanes, workmen struck underground water, which resulted in costs that ran to $600,000—a high price indeed for lanes that were allegedly never used.

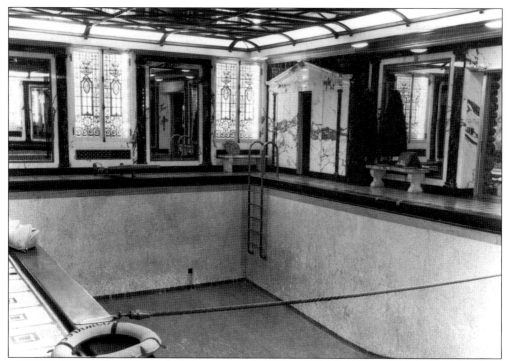

At the east end of the lower level was a swimming pool decorated in a Pompeiian motif, with marble walls, shower stalls, dressing rooms, and a gold-tinted, mirrored ceiling that simulated sunlight. The pool remains covered so the room can provide classroom space.

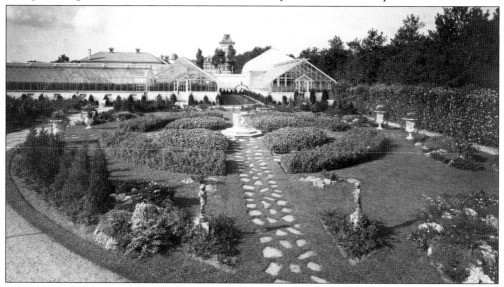

Parson expanded McCall's 65-acre property to 108 acres, half of which was designated for farming. Components of Shadow Lawn then grew to include eight greenhouses, a 10-room house for the superintendent, a two-story garage, a horse barn with six stalls, cottages for the dairyman, the greenhouse man, and the poultryman, dog kennels for Parson's police dogs that were allowed to run free on the grounds every midnight, a cattle barn with 12 stanchions, a poultry house, ram, sheep, pheasant, and bull pens, rabbit hutches, and an icehouse.

Leonie Bernheim Guggenheim, born in 1866 in France, married Murry Guggenheim in 1887 and gave birth to their son Edmond the following year. The youngest daughter of a wealthy textile manufacturer in France, Leonie met Murry when he was on a business trip to Europe. Leonie died in 1959.

Murry Guggenheim (1858–1939) was the third of eight sons born to Meyer and Barbara Guggenheim, who also had three daughters. A Swiss-born Jew, Meyer and his family immigrated to Philadelphia in 1848, when he was 20. On the ship to America, Meyer met Barbara Meyers, married her four years later, and pursued his trade of peddling notions, including a stove polish he began to manufacture himself. He later went into the lace and embroidery business, but his sons, including Murry, were to become mining magnates. Murry was president of the family's $1,500,000 Philadelphia Smelting and Refining Company.

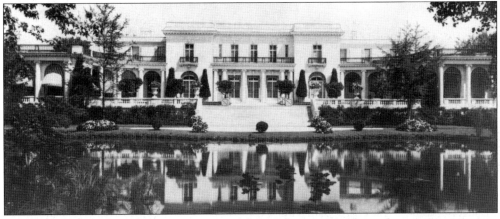

The south facade of the 35-room Guggenheim Cottage in 1906 holds a slight reminiscence of the Taj Mahal in India, particularly as it is so beautifully reflected in the water. The only Guggenheim mansion still standing in this area, the cottage (now the Guggenheim Memorial Library of Monmouth University) was designed by the architectural firm of Carrère and Hastings, who won the gold medal of the New York Chapter of the American Institute of Architects in 1903 for the cottage, which was not completed until 1905. Guggenheim purchased the land for the cottage from the estate of Norman L. Munro in 1903. In the late 1890s, Pres. William McKinley and Vice Pres. Garret A. Hobart paid a summer visit to Munro's estate, Normanhurst, which is now the site of the Guggenheim Library.

The Guggenheim Cottage, intended for summer use, had porches, or arcades, curving from the east and west sides of the building, which created lovely embraces for the gardens and the pond.

The main entrance to the white stucco Guggenheim Cottage was on the north side and under a stately porte-cochere. According to the autobiography of Peggy Guggenheim (Murry Guggenheim's niece who owned an art gallery in New York and championed the work of Jackson Pollock), Murry Guggenheim "had an Alsatian wife (Leonie) and with her French taste they built a house which was an exact copy of the Petit Trianon at Versailles."

An interior view of the porch of the Guggenheim Cottage indicates the white color scheme throughout the house. Interestingly, the white theme is also represented in the Solomon R. Guggenheim Museum in New York City. Solomon Guggenheim (1861–1949) was Murry Guggenheim's brother and the fourth son of Meyer and Barbara Guggenheim.

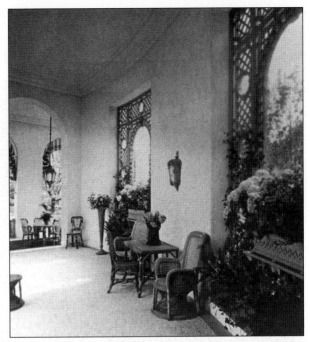

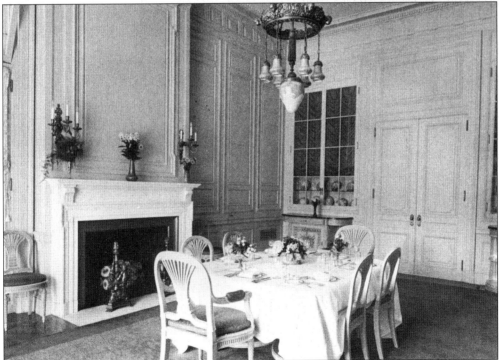

The spacious dining room of the cottage reflects the summery, light ambience that the Guggenheims preferred. According to Marion Landew in the September 1986 edition of *New Jersey Living* magazine, "the house was enjoyed for many summers by Leonie and Murry and their two children, unlike the tragically brief residence of the Parsons in nearby Shadow Lawn. Even after Murry died in 1939, Leonie continued her visits . . . for the next 20 (summers)."

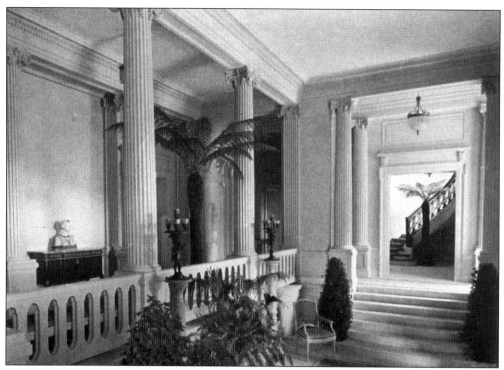

The Guggenheims' rectangular reception hall had stairways at either end that led to the main hall and a circular reception room.

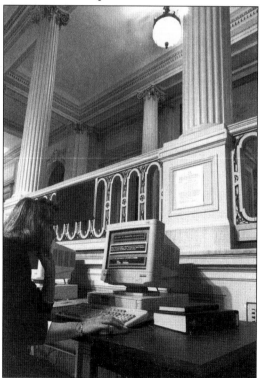

After Leonie Guggenheim died in 1959, the estate became the property of the Murry and Leonie Guggenheim Foundation, which was run by their son Edmond. The reception hall area now contains computers for students to access the collections of the library.

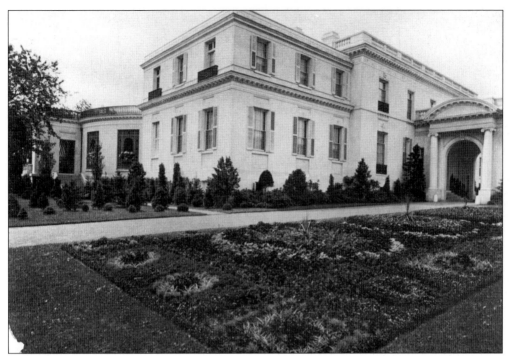

One well-ordered garden on the Guggenheim estate resembles a large hand-woven carpet.

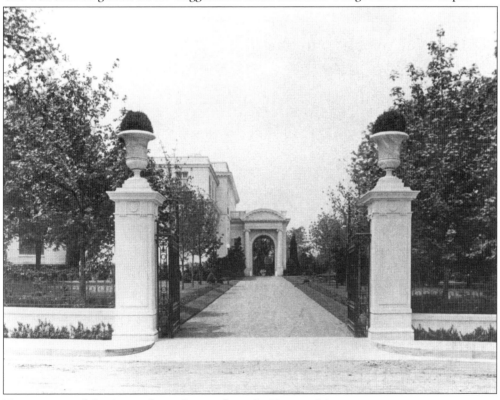

This is a view of the Guggenheim Cottage from the Norwood Avenue gate.

The Guggenheims (or so this photograph has often been identified) pose with a horse-drawn cart outside the cottage.

The Guggenheims also built a stable and carriage house on the south side of Cedar Avenue and to the east of the cottage. It was donated by the Guggenheim Foundation to Monmouth College in 1961. In 1967, the building opened as the Performing Arts Center, renamed the Guggenheim Theatre in 1978. Today it is known as the Lauren K. Woods Theatre.

The horse stalls of the former carriage house and stable, where the horses enjoyed shelter and grooming, served as makeup cubicles and dressing rooms for the newly renovated 155-seat theater.

The original carriage house, which had an apartment for the superintendent and a summer apartment for the butler on the second floor, was to become the facility for the college's then Speech, Communication and Theatre Department.

This statue, one of the numerous statues on the Guggenheim estate, is said to have been modeled after Leonie Guggenheim.

One of the bedrooms in the Guggenheim Cottage is pictured here. The cottage was placed on the State Register of Historic Places in 1977 and on the National Register of Historic Places in 1978.

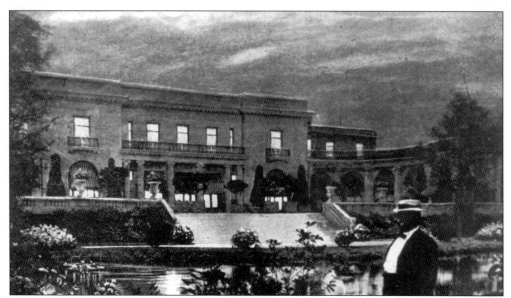

Here again is the south facade of the Guggenheim Cottage, at the corner of Cedar and Norwood Avenues. Cedar Avenue extends from Long Branch into West Long Branch and is Monmouth University's official address in Monmouth County. There are many Roman, Celtic, Norman, and Breton references to the historic name Monmouth, which is an attractive market and border town in southeastern England, west of Gloucester and within an hour's drive from Hereford, Bristol, and Cardiff. Associated with the name Monmouth are Geoffrey of Monmouth (born *c.* 1090), translator of the *History of the British Kings* manuscript; Henry V, who was born in Monmouth Castle in 1387; Monmouth Gaol, a medieval fortress demolished in 1884, and the Royal Monmouthshire Royal Engineers (militia) from 1539.

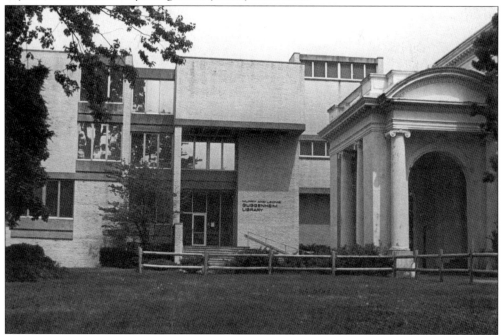

An addition to the Murry and Leonie Guggenheim Library was dedicated on May 4, 1968.

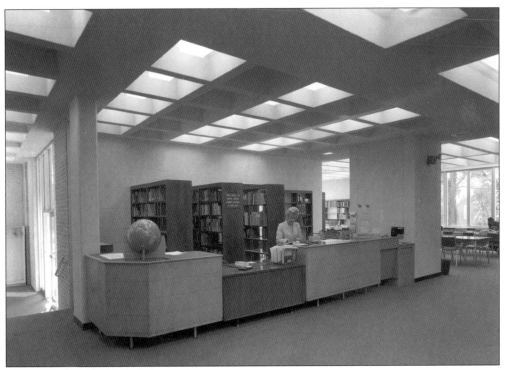

The circulation desk is shown here in the new addition to the library.

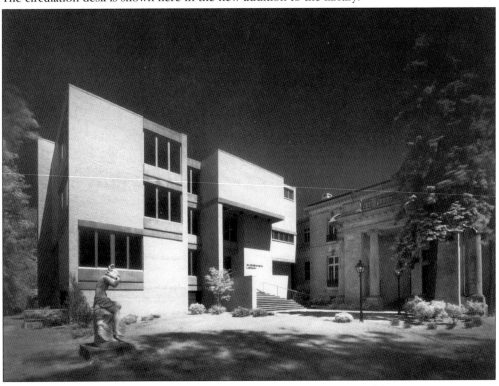

Bold, modern, and somewhat monolithic qualities define the library's addition.

Three

A College Is Born

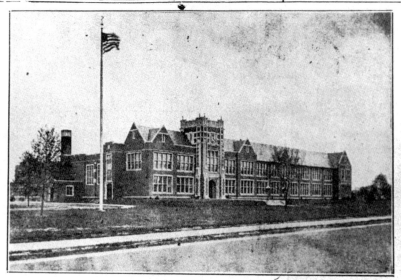

ASBURY PARK SUNDAY PRESS
THE SHORE PRESS

VOLUME LV. NO. 25. ASBURY PARK, N. J., DECEMBER 17, 1933 FEATURE SECTION

The Long Branch Senior High School building, where nearly 400 Monmouth countians are acquiring culture after working hours at a price they can afford to pa

Learning Comes to the Public

Monmouth Junior College, Designed to Fill a Depression
Need, Promises to Become a Valuable Fixture

Headlines of December 17, 1933, broke the news of the establishment of Monmouth Junior College, which offered classes after 4:00 p.m. in Long Branch Senior High School. Under the auspices of Dean Edward G. Schlaefer, the college was welcomed by Monmouth County as a cultural and educational hub. The concept of a junior college became popular in western states and caught on in the east as well. Four hundred students eagerly registered for classes soon after the college opened its doors. A permanent building lay in the school's destiny, however, and perhaps it was a collective dream of the future to create a university.

The first administration building of Monmouth Junior College was at 422 Westwood Avenue in Long Branch, directly across the street from the high school.

Founding director of Monmouth Junior College, Edward G. Schlaefer was a native New Yorker whose doctoral thesis gave an account of beginning teachers in the schools of northern New Jersey. A graduate of Columbia University, Schlaefer served as executive vice president under Eugene H. Lehman and was responsible for most of the college's administrative duties. He was also president of the American Association of Junior Colleges and other organizations.

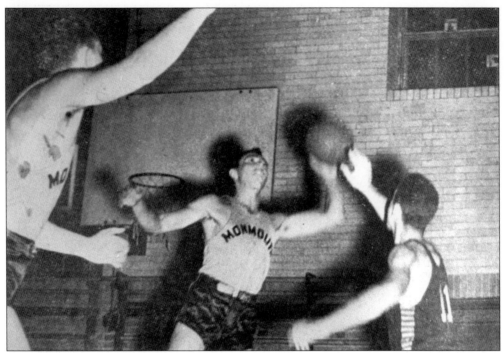

The Monmouth Junior College basketball players were referred to as the "Night Hawks" because they could only play or practice at night.

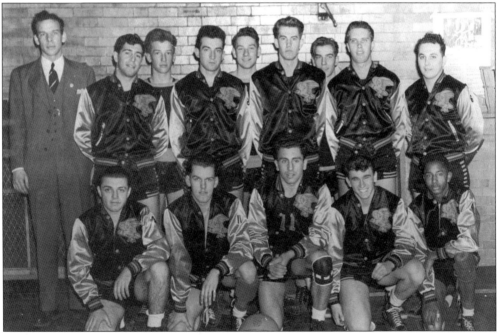

Pictured is the 1941–1942 Monmouth Junior College team. From left to right are the following: (front row) Gene Masco, Dick Rogers, Frank Cioffi, Moe Fribaum, and Ivan Ware; (middle row) Garry Penta, Bill Custer, Bill Taylor, Brad Parker, and Al Kroner; (back row) coach Art Brown, Russ Wilder, Stanley Wolpin, and Donald Mayer.

WHAT WILL BE YOUR LIFE WORK?

A brochure listing the training and programs offered by Monmouth Junior College served as a precursor to a college catalog.

Future success means education now. Monmouth Junior College can give you the preliminary college training required or advised in more than 40 professions or fields of work. These include:

MEDICINE
TEACHING
 PHARMACY
 LAW
 NURSING
 JOURNALISM
 DENTISTRY
 LIBRARY SCIENCE
 AERONAUTICS
 ENGINEERING
 (Electrical, Civil,
 Mechanical, Chemical)
STATISTICS
 INDUSTRIAL RESEARCH
 SOCIAL WORK
 DIPLOMATIC SERVICE
 CRIMINOLOGY
 PERSONNEL WORK
 CIVIL SERVICE
 BUSINESS MANAGEMENT
 ACCOUNTING
 MERCHANDISING
 SECRETARIAL WORK

MONMOUTH JUNIOR COLLEGE

Long Branch · New Jersey

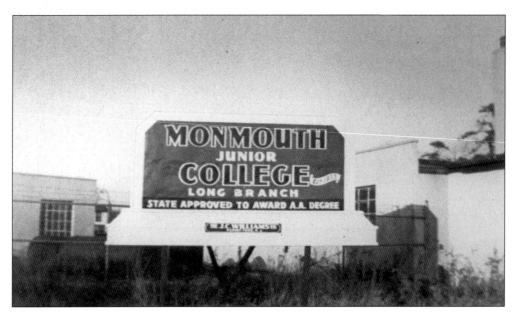

This *c.* 1940s billboard was located across the street from the Long Branch train station on Third Avenue.

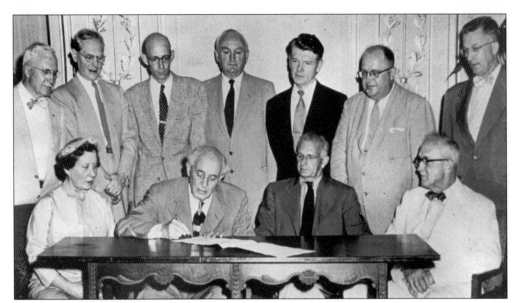

Eugene H. Lehman—owner and director of the Highland Manor School for Girls, which relocated from Tarrytown-on-Hudson, New York, to the Shadow Lawn mansion in West Long Branch—signs over the deed to the Shadow Lawn estate to Monmouth Junior College in 1955. Lehman purchased the estate from the borough for $100,000 in 1942. The college paid $350,000. The woman sitting on the far left may be Lehman's wife, Eleanor.

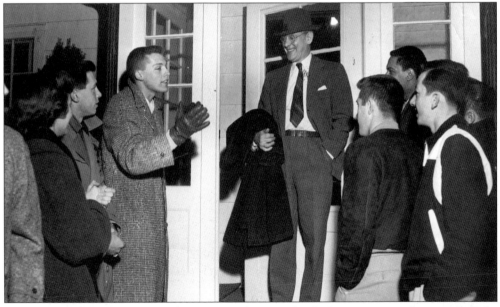

Dean Edward G. Schlaefer leaves 422 Westwood Avenue for the last time, as students applaud the impending move to West Long Branch. Titles to the Shadow Lawn and Beechwood estates passed to the college on July 2, 1956, and classes started on September 23 in the new location. That same year, the New Jersey Department of Higher Education authorized the college to grant four-year degrees in English, history, foreign languages, and psychology. A bachelor of science degree recognized biology, business administration, physics, and mathematics majors. Two years after the move, the college awarded its first four-year baccalaureate degrees and became Monmouth College.

Eugene H. Lehman served as first president of Monmouth College from 1956 to 1957. One of his conditions of the sale of the Shadow Lawn estate was that he be made president. The college agreed to grant him a one-year term. Lehman, of Colorado, earned bachelor's and master's degrees from Yale and was the first American to win a Rhodes Scholarship. He did graduate work also at Columbia and at the University of Berlin. At Yale, he taught biblical literature. In 1910, he founded one of the first girls' camps in the nation, in South Naples, Maine. He also served as director of the Lehman-Leete School for Girls in New York City from 1915 to 1919.

Shortly before Monmouth College occupied Shadow Lawn, the Highland Manor School for Girls held a graduation ceremony. During the 1940s, actress Lauren Bacall attended the school as a teenager, when her name was Betty Joan Perske. She was born on September 16, 1924.

Four

THE NEXT BEST MOVE

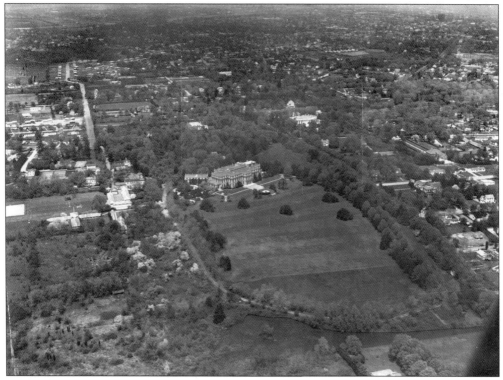

This aerial view of Shadow Lawn, the Guggenheim Cottage (just above and to the right of Wilson Hall), and grounds probably dates from about the time that the college purchased the estate in 1956.

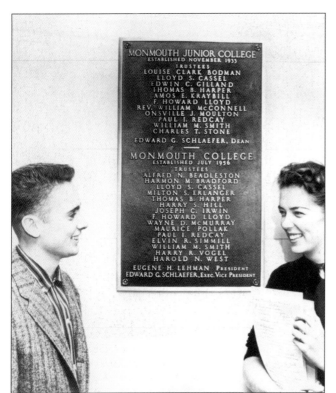

A plaque was installed at Wilson Hall to honor the founding trustees of Monmouth Junior College in November 1933, and Monmouth College in July 1956.

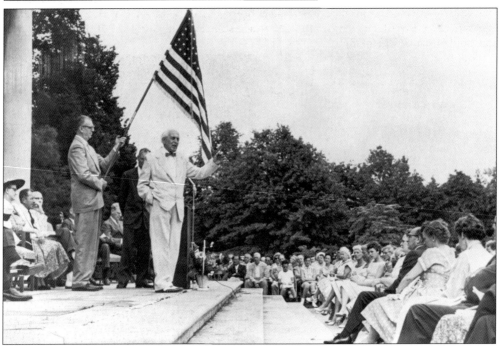

At the first Monmouth College commencement in 1957, Pres. Eugene H. Lehman addressed the graduates on the new campus at Shadow Lawn's south portico. Shadow Lawn was soon renamed Woodrow Wilson Hall.

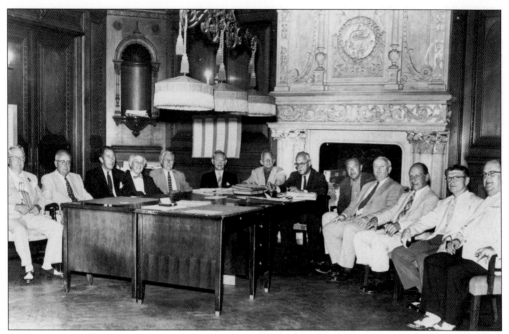

On July 26, 1956, the board of trustees met in Wilson Hall. From left to right, they are F. Howard Lloyd, Harry C. Vogel, Joseph C. Irwin, Eugene H. Lehman, Harmon M. Bradford, Edward G. Schlaefer (executive vice president of the college), Thomas B. Harper (vice president of the board), Lloyd S. Cassel (board secretary), Elvin R. Simmill, Paul I. Redcay, Milton S. Erlanger, Milton Kramer (board attorney), and Harold N. West (board treasurer). Not pictured are William M. Smith (board president), Hon. Alfred N. Beadleston, and Dr. Harry S. Hill. This photograph appeared in the college yearbook in 1957.

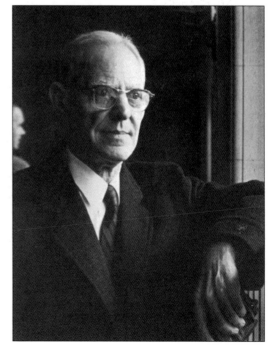

Edward G. Schlaefer served as president of Monmouth College from 1957 to 1962. Named for Schlaefer, the Schlaefer School (established in the mid-1990s) offers the student who shows academic promise but has not met the regular admission requirements a chance for collegiate success through intensive guidance and special instruction.

Edward G. Schlaefer and his wife, Bernice, joined some 150 members of the faculty and administration and their families at the college's annual picnic weekend, May 21, 1961, held at Telegraph Hill Park in Holmdel Township (Monmouth County).

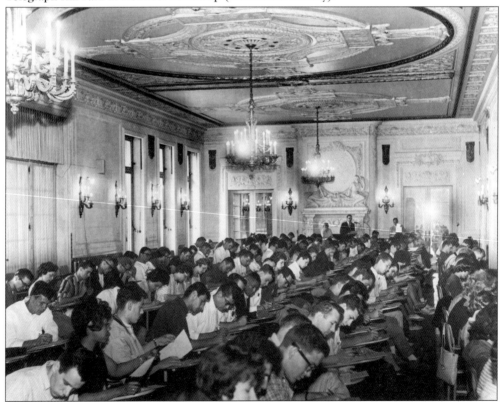

Students take final exams in the Great Hall of Wilson Hall.

The gilded walls of the former music room in the Parsons' mansion are pictured here. The room today is the financial aid office.

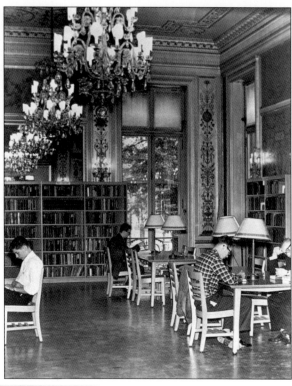

Any class held in Wilson Hall must certainly have been an experience in history, not to mention the opulent light fixtures, fireplaces, and architecturally intriguing ceilings, walls, doors, windows, and floors.

The elegantly paneled Versailles Room in Wilson Hall was the student dining hall in the early days of the college. Note the freshman wearing a dink, which was required headgear for freshmen everywhere during the 1960s.

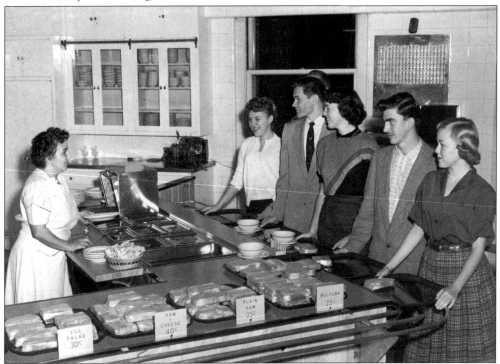

Now the bursar's office, the Monmouth College food service included, astoundingly, a 40¢ ham and cheese sandwich and, for a nickel less, one could hold the cheese.

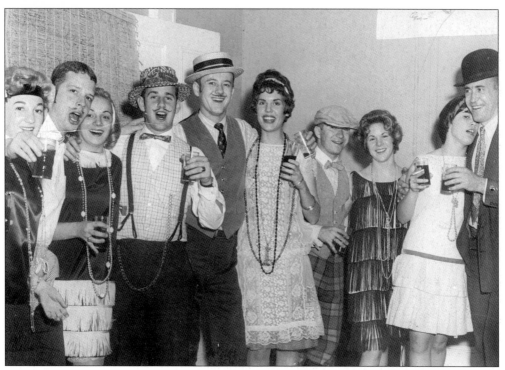

Social life emerged among the student body members, to which this costumed group attests.

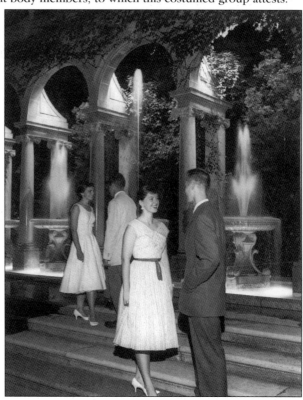

In the summer of 1959, the school held more formal social events.

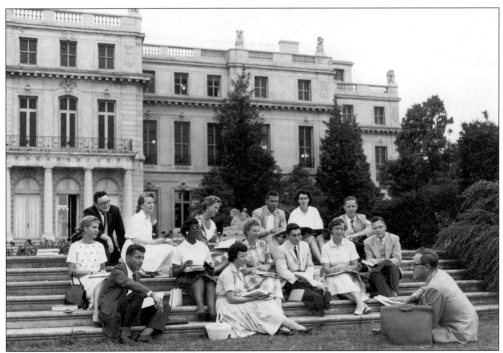

Classes in the 1960s often took advantage of nice weather and beautiful surroundings, such as the steps of Wilson Hall.

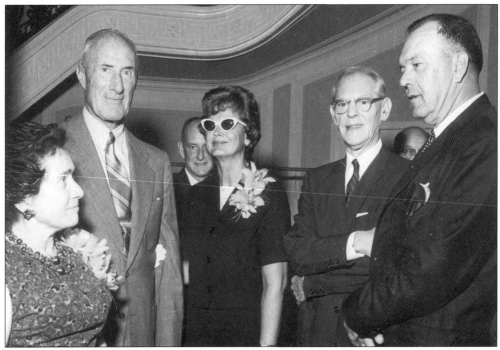

On September 9, 1960, Mr. and Mrs. Edmond A. Guggenheim (second and third from left) and Edward G. Schlaefer, among others, transferred ownership of the Guggenheim Cottage to Monmouth College.

Freshmen wearing dinks, the required freshman orientation headgear at colleges throughout the country, stop at the park bench on the main Wilson Hall footpath.

Some freshmen pose at the foot of a huge column on the front steps of Wilson Hall, flanking the engraved emblem lauding "truth, service, and leadership."

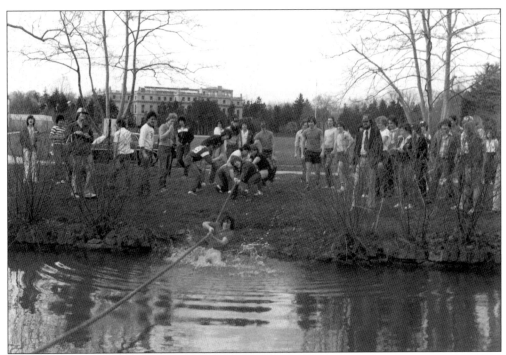

The tug-of-war across the campus' Whale Pond Brook has long been abandoned as a sporting event at Monmouth College.

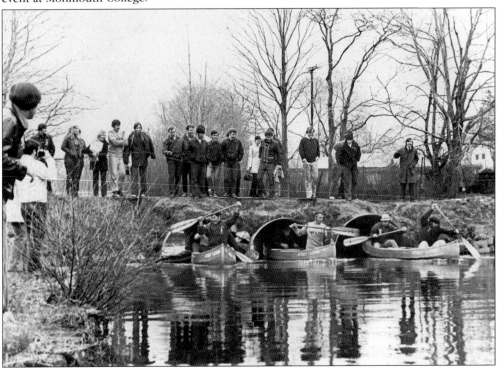

Also on Whale Pond Brook, students in the college's early days enjoyed canoe races. The canoes were rented from (or possibly donated by) Sunset Landing in Wanamassa.

Dr. William G. Van Note served as president of Monmouth College from 1962 to 1971. Van Note—who was president of Clarkson College in Potsdam, New York, for 10 years before his appointment as president of Monmouth—saw an increase of the budget from $2.4 million in 1962 to $10.5 million at his retirement in 1971. Enrollment also increased during his administration, from 2,884 students to approximately 6,000. The faculty grew from 135 members to 314. Under the Atlantic Highlands native, Monmouth College began offering master's degrees. A former metallurgist with a degree in chemical engineering, Van Note taught metallurgical engineering at McGill University and chemistry at the University of Vermont. He also served for 18 years at North Carolina State College, rising from instructor to director of the Department of Engineering Research. He became president of Clarkson in 1951 and received honorary degrees from St. Lawrence University and North Carolina State College.

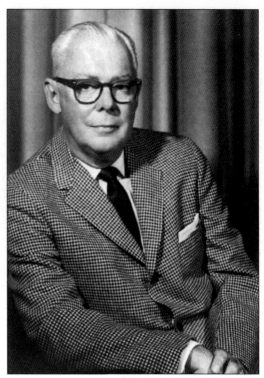

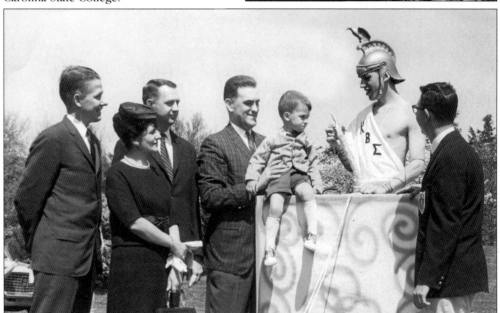

A Greek Chariot Race on a May 4 during the college's early history was held by Theta Epsilon Chi in conjunction with Spring Weekend. The purpose was to raise money for the Dr. Schlaefer Memorial Scholarship fund. Pictured from left to right are Charles Ritscher; Adele Madore, alumni president; Jay Petersen, alumni secretary; William Apostolacus, alumni vice president and his son Billy Apostolacus; Jerry Goldstein, of the Kappa Beta Sigma fraternity; and George Grodberg, of Theta Epsilon Chi.

Tau Kappa Epsilon fraternity brothers of Monmouth College's first fraternity, according to the banner, pose at their house either on Cedar or Norwood Avenue in the mid-1960s.

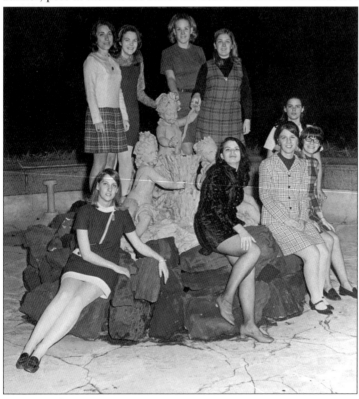

In this 1960s view, sorority sisters pose around the fountain on the south side of Wilson Hall.

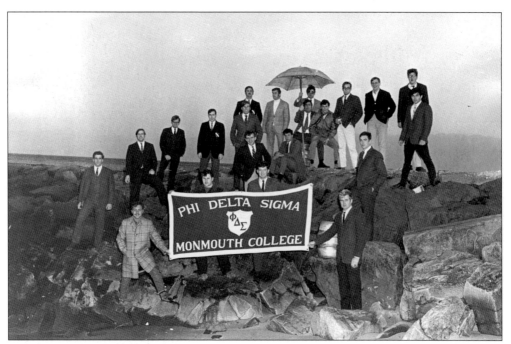

Phi Delta Sigma brothers, including Edward Dalton (center, back row, with moustache), Jimmy Wilson, Tommy Hopkins, Jackie Hayes, Dave Foster, and Mark Reed, prefer to pose on a jetty that represents Monmouth College's proximity to the Atlantic Ocean.

A sorority stands on the beach in the late 1960s or early 1970s.

The members of this fraternity clearly followed the theory of Benjamin Franklin, who allegedly said that God gave us beer because he loves us and wants us to be happy.

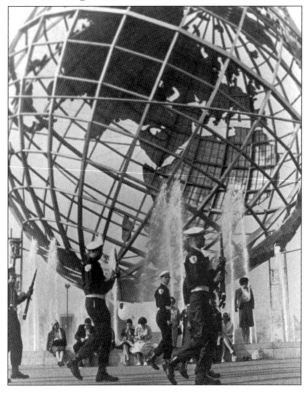

The Monmouth Blue Grenadiers drill team performs at the New York World's Fair in 1964.

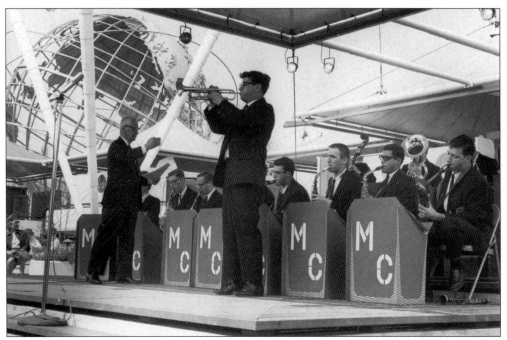

Tommy Tucker leads the Monmouth College Band at the 1964 World's Fair in New York. This was one of the photographs in the exhibit "Ralph Binder: The Monmouth Years" at the 800 Gallery in March 1993.

This bird's-eye view, looking west from the top of Wilson Hall, shows vacant areas later to be occupied by Edison Science Hall and the College Center.

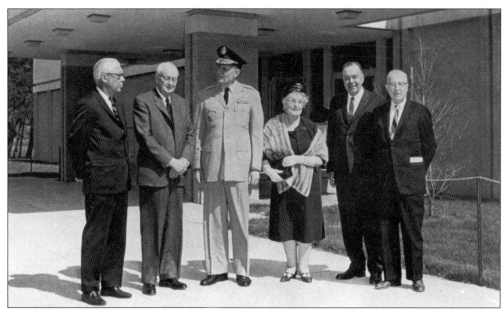

Among the guests at the May 7, 1966 dedication and opening of Thomas Alva Edison Science Hall are, from left to right, Pres. William G. Van Note, Dr. Wayne A. McMurray, Brig. Gen. William B. Latta (commanding general of the U.S. Army Electronics Command), Madeleine Sloane (Thomas Edison's daughter), Superior Court Judge Elvin R. Simmill (chairman of the college's board of trustees), and John Sloane (Madeleine's husband).

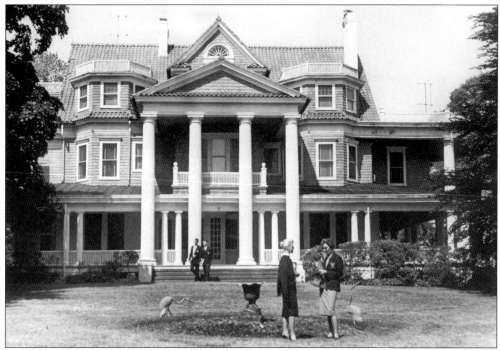

Former Monmouth County freeholder Victor E. Grossinger bequeathed this *c.* 1900 mansion, which was the former Brookside estate main house, to Monmouth College. Grossinger was a realtor of Red Bank. He died on July 18, 1981.

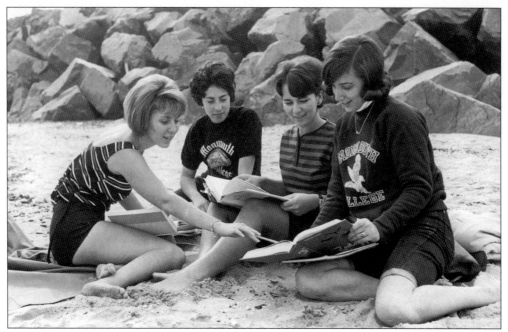

The Long Branch beach was a great place to study. These students are shown on the beach in the 1960s.

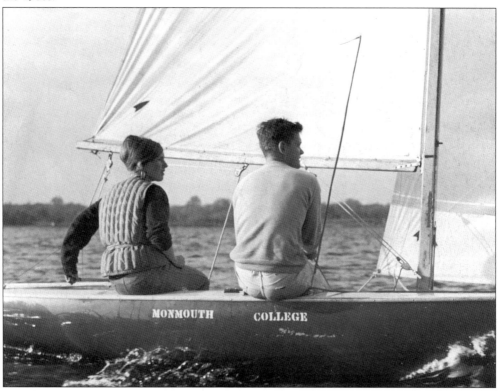

In 1969, Monmouth College had a sailing team, making wonderful use of the college's location near the ocean.

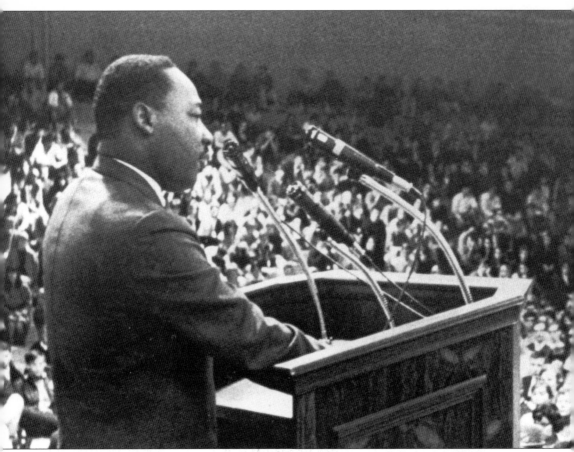

On October 6, 1966, Dr. Martin Luther King Jr. spoke at Monmouth College and (according to the college newspaper, the *Outlook*) initiated the Monmouth College Student Union Lecture Series. An eloquent Baptist minister who led the civil rights movement in the United States from the mid-1950s, King was assassinated on April 4, 1968, in Memphis, Tennessee. He was born in Atlanta, Georgia, on January 15, 1929, and rose to national prominence through the Southern Christian Leadership Conference, whose mission was to promote nonviolent change in favor of racial, socioeconomic, and religious tolerance for all people. His nonviolent strategies led to a Nobel Peace Prize in 1964.

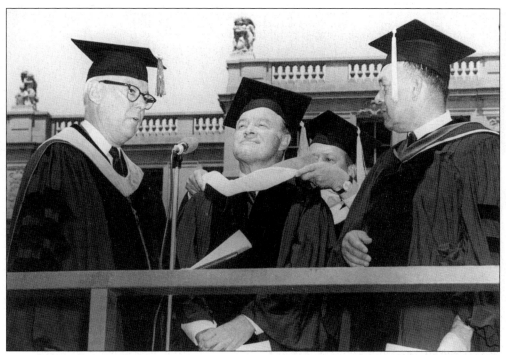

In 1965, Monmouth College conferred an honorary degree upon comedian and actor Bob Hope (center).

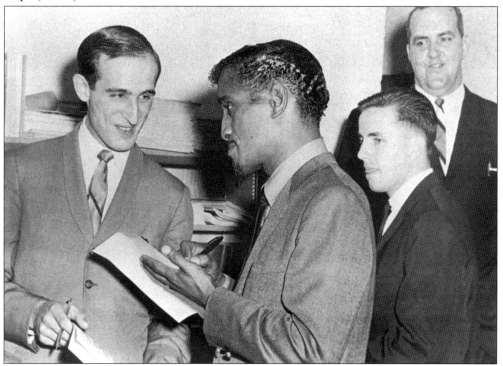

During the 1960s, Sammy Davis Jr. gave a concert in the gymnasium. To the far right in the back is Tom Murtha, a retired physical education professor who was then a student life administrator.

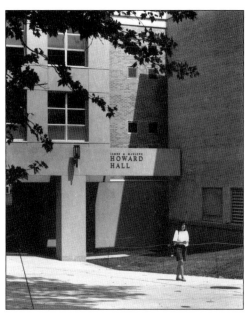

The 500 Building on the campus was rededicated as James and Marlene Howard Hall in the 1980s. Congressman James Howard is still remembered as chairman of the House committee on transportation. The 500 Building, built with government money, had originally been designated a center for the study of transportation issues. Howard did not live to see the Howard Hall dedication ceremony.

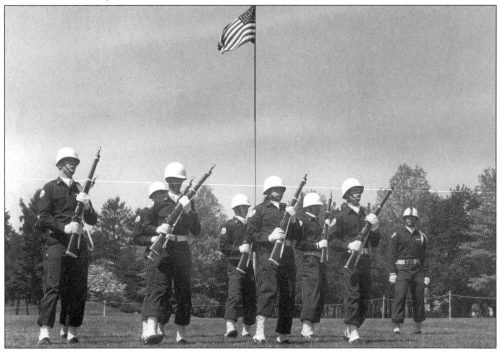

The Monmouth College Blue Grenadiers drill team practices a military formation on the grounds of the campus. The team, commanded by Peter Catelli in the early 1960s, no longer exists at Monmouth.

Players make the first jump ball in the new gymnasium, which was called Memorial Gymnasium before it was renamed the William H. Boylan Gymnasium in 1989.

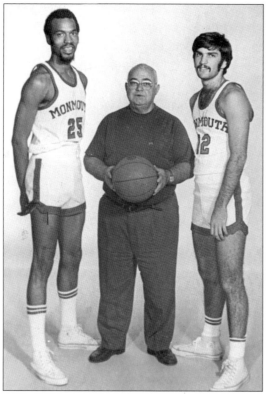

One of the most successful basketball coaches in the history of Monmouth College, William Boylan (center), stands with team members Gary Massa and Ron McDowell. Boylan was coach from 1956 to 1977, compiling a record of 367-157. He directed the Hawks to five NAIA District 31 titles. He was also president of the Metropolitan Basketball Association.

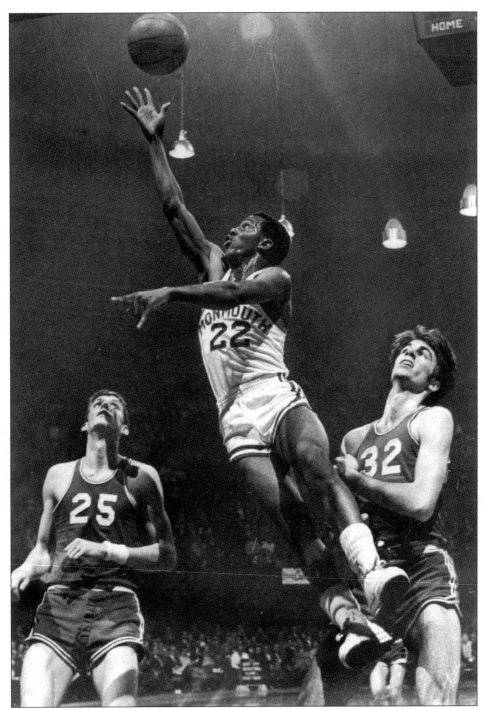

Ron Kornegay, No. 22 on the Monmouth College basketball team, is veritably airborne in this picture. Kornegay played when Monmouth was considered a small school, not yet participating in the National Collegiate Athletic Association (NCAA). He was the most famous basketball player in Monmouth College history as a National Association of Intercollegiate Athletics (NAIA) All-American. His number was the first basketball number to be retired, at a ceremony in 1998.

Ron Kornegay came back to his alma mater to take over as head basketball coach. Today he is the beloved athletic director at Manasquan High School in Manasquan.

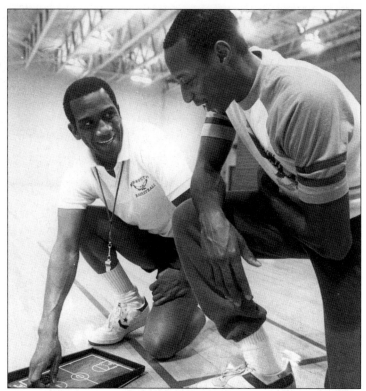

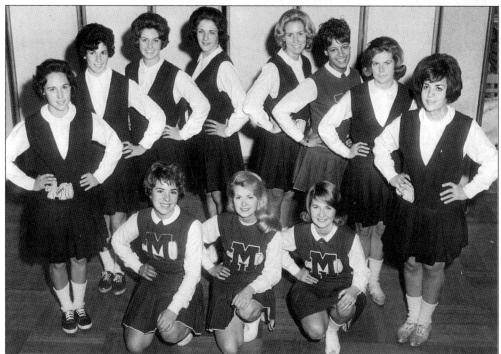

Smiling for the camera are some of Monmouth College's earliest cheerleaders. Skirts have certainly gotten shorter for cheerleaders since then.

The Vietnam War sparked many a protest on college campuses. This one took place at Monmouth College.

Folksinger Jill Willinger performs at a Moratorium Day event at the college on October 15, 1969. The *Asbury Park Press* reported that the audience was reluctant to join in the song.

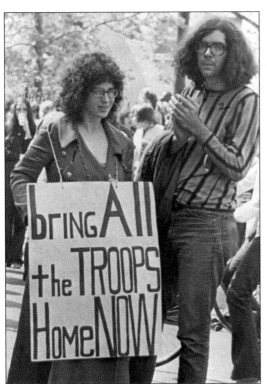

By the spring of 1979, student protesters were demanding that all those who served in Vietnam be brought home.

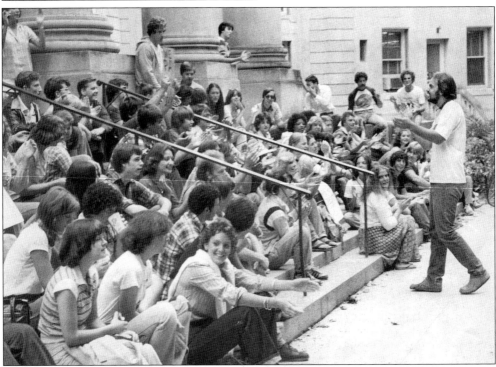

Student government president John DeGenito talks to a group of college students at Wilson Hall on September 11, 1979.

Mr. and Mrs. Maurice Pollak, benefactors of Monmouth College, bequeathed their home and property to Monmouth. This eventually led to the creation of the Pollak Auditorium, which was renamed the Pollak Theatre on July 1, 2000. The new name reflects the character of the facility, which serves as the university's venue for performing arts events. The Maurice Pollak Award for Distinguished Community Service is given each year on Founder's Day.

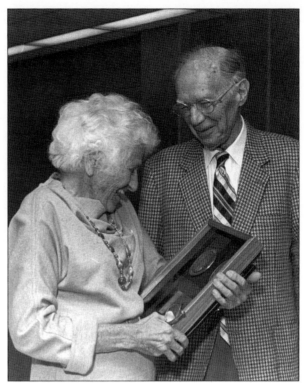

From 1971 to 1979, Richard Stonesifer was president of Monmouth College. During his tenure, he doubled the number of master's degree programs and oversaw the construction of the student center. He served previously as dean of the College of Liberal Arts at Drew University and is the author of the book *W.H. Davies: A Critical Biography*. In his early career, he was an assistant professor of English and later the assistant to the president and director of public relations at Franklin and Marshall College. From 1963 to 1965, he served as assistant to the provost at the University of Pennsylvania.

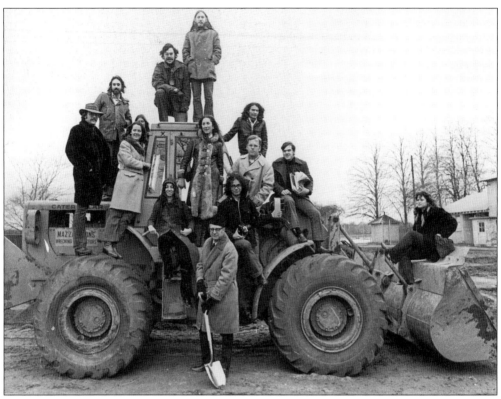

In 1973, construction of the College Center began at Monmouth College. Pres. Richard Stonesifer holds a shovel as students pose atop a tractor at the groundbreaking ceremony.

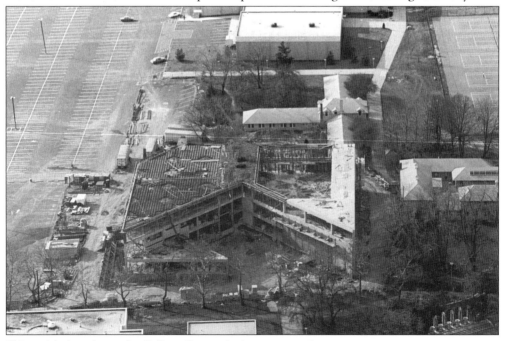

This aerial view shows the College Center during construction.

Students enjoy the outdoor swimming pool on the north lawn of Wilson Hall. The pool no longer exists.

Actor Vincent Price chats with Monmouth College students in 1968. He participated as a speaker in the college's lecture series that year. The series also included talks by Mike Wallace, Ann Landers, and Elizabeth Janeway. Price was well known for his role in the movie *Laura* and for his many other films.

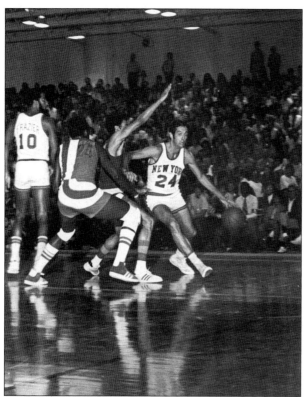

In the early 1970s, Bill Bradley, Walt Frazier, and Willis Reed of the New York Knicks play a preseason exhibition game at the William H. Boylan Gymnasium. For a number of years, the Knicks operated their training camp at Monmouth College. The New York Giants football team also used the field at Monmouth College during training camp.

Prof. Robert Pike is pictured here in the Monmouth College language lab. He served as a language instructor at the college for more than 30 years.

Drum majorettes in the 1960s pose on the Wilson Hall steps that now lead to the College Center. The group also performed at the New York World's Fair.

Intramural football was popular in the 1960s and 1970s. The teams had names like the Chinese Bandits and the Sportsman's Club. The university still holds intramural football games.

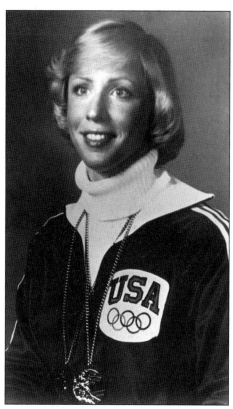

Wendy Boglioli (Class of 1977) won a gold and a bronze medal in swimming at the 1976 Summer Olympics in Montreal while she was still a student at Monmouth.

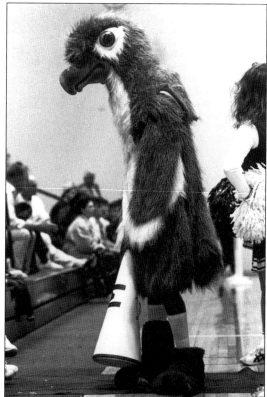

One of the earlier versions of the school's mascot, the Hawk, is seen here with a megaphone.

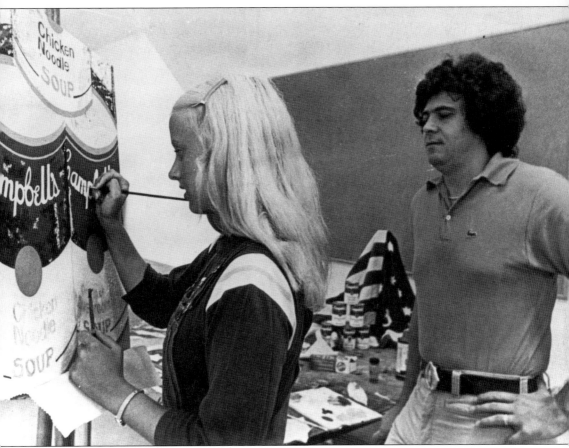

Vincent DiMattio, who became head of the university's art department, observes a student as she paints a canvas inspired by the Campbell's soup cans that Pop artist Andy Warhol made famous for far more than 15 minutes.

Ralph Binder, director of the Instructional Media Center at Monmouth College, participated as an interviewee for the Oral History Project in March 1990. A photographer at Monmouth Junior College in 1948, Binder started his career at Monmouth in 1963 as an administrative assistant in the public information office. "My most memorable time . . . was when the Vietnam demonstrations took place on campus," Binder told interviewer Frances Reich. "I had many memorable photo assignments at Monmouth because of all the prominent people who have visited the campus. . . . I would have to list John Huston as the most impressive visitor, possibly because we had a one-on-one lengthy encounter when I was assigned to take his portrait." Binder is listed in the register as one the freshmen who completed courses at Monmouth Junior College in 1934–1935.

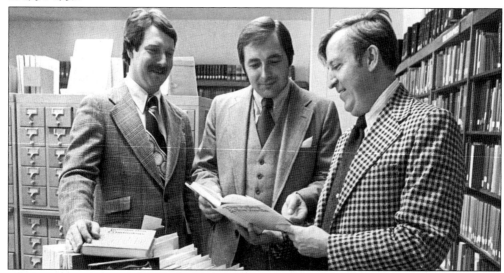

Robert F. Van Benthuysen, shown with Jeff Broten (left) and John Winterstella (center), was a Monmouth librarian who took a special interest in preserving the history of Monmouth College. He wrote *Crossroads Mansions: Shadow Lawn and the Guggenheim Cottage* (1987). His writings and bibliography made it possible to understand the roots of the school and continue gathering information on the college's past for future volumes and archives. Van Benthuysen also coauthored *The Early History of West Long Branch, New Jersey* (1977) with historian Charles H. Maps.

The Guggenheim carriage house became the Guggenheim Theatre on Cedar Avenue. Prof. Lauren K. Woods III, known to everyone as "Woody," directed more than 100 student shows at Monmouth College. For nine years before he died in 1995, he produced, directed, and acted in Monmouth University's three-show summer season. A Fair Haven resident, he also appeared in more than 250 television commercials as well as in a television series. "He was the policeman in a Dr Pepper commercial, the lovable husband in a Hershey's Syrup commercial and the honest-faced butcher in a Milk-Bone commercial," it read in his obituary in the *Asbury Park Press*. Woods's wife, Ellen Terry Woods, joined her husband in many a show, and the two had small parts in the movie *Annie,* filmed at Wilson Hall in 1981.

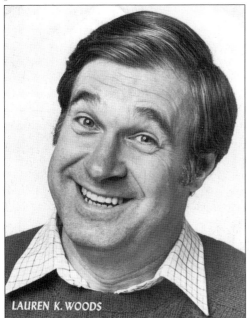

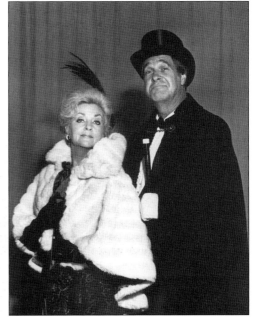

Left: Prof. Lauren K. "Woody" Woods flashes his unforgettable smile in the 1980s. *Right:* Woody and his wife, Ellen, are dressed for showtime.

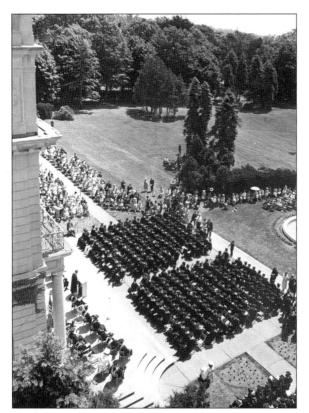

This graduation ceremony dates itself as one of the earliest (possibly the 1960s) because the graduates are still few enough to fit on the steps of Wilson Hall. Later, as more and more students received degrees, commencement expanded onto the Great Lawn.

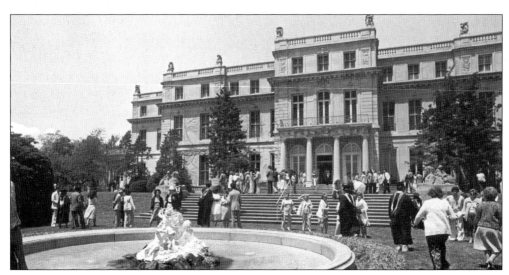

Graduation of May 1979 was obviously a sunny day and one of endless festivities for the graduates, their families, and friends.

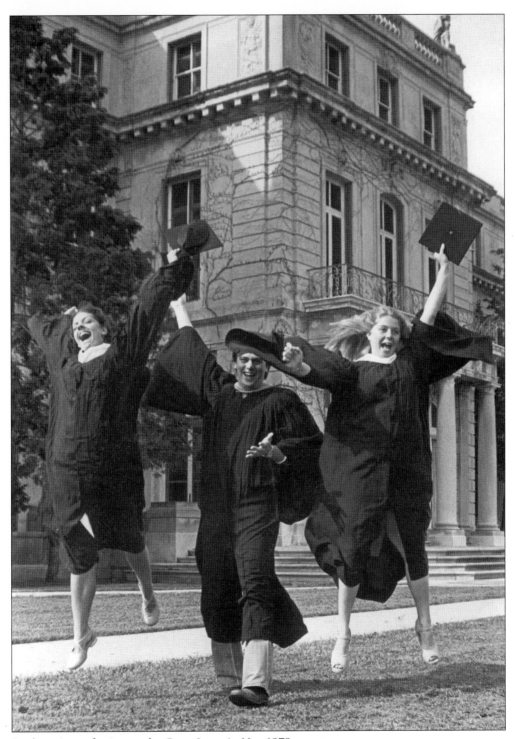

Students jump for joy on the Great Lawn in May 1979.

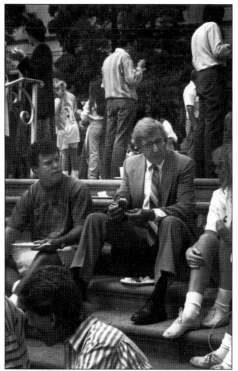

Samuel Magill, president of the college from 1980 to 1993, did not care much for headshots and preferred always to be pictured in candids, such as this one in which he sits on the Wilson Hall steps and chats with students. A Georgia native, Magill spent much of his childhood in Shanghai, China, where his father was stationed as senior executive of the Young Men's Christian Association (YMCA). With a doctorate in Christian ethics, political theory, and American religious studies from Duke University and two baccalaureate degrees (one in religion in higher education and social ethics from Yale), Magill taught religion at Dickinson College, where he became dean. After other college presidencies, he was appointed president of Monmouth and thereafter established the Governor's School for Public Issues, oversaw an ambitious capital projects plan and the renovation of Wilson Hall, upgraded the athletics program to Division I, and paved the way for the football program. He was also the driving force behind changing state regulations to allow colleges such as Monmouth to be designated universities.

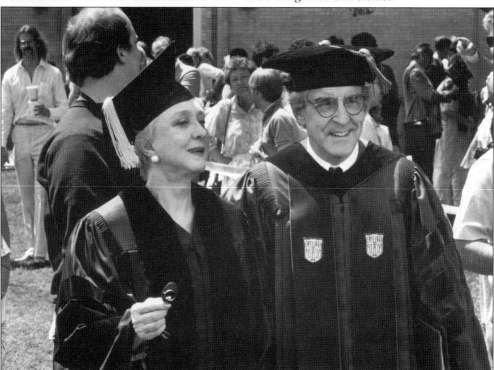

In 1987, Monmouth College gave actress Celeste Holm an honorary degree. She is seen here talking with Samuel Magill.

An invitation to the 1982 benefit premiere of *Annie,* in which Wilson Hall became the palatial home of the character Daddy Warbucks, ranked the filming of the movie as a major cultural phenomenon at the college.

Monmouth College

requests the honour
of your presence at the
BENEFIT PREMIERE
of the motion picture

on Thursday, the twenty-seventh of May
nineteen hundred and eighty two
at six o'clock in the evening

Woodrow Wilson Hall
Monmouth College
West Long Branch, New Jersey

Cocktails, candlelight dinner and dancing
will begin at nine o'clock.
Black tie: optional

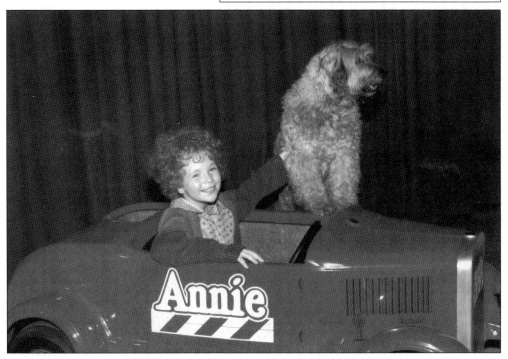

Eileen Quinn, the adorable redhead who played the starring role in *Annie,* pets another star—the dog who plays the orphan's companion, Sandy.

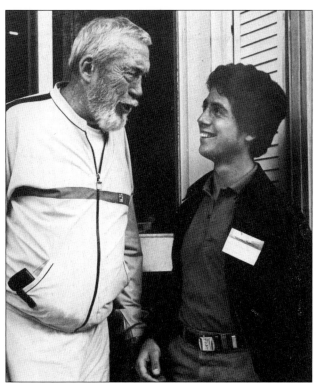

Director John Huston takes the time to talk to a Monmouth College student during the time the filming crew was on campus. Huston received an honorary degree from Monmouth College in 1981.

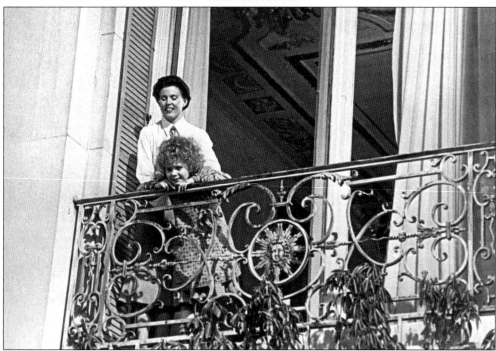

Young actress Eileen Quinn looks over the balcony of Wilson Hall, seen in the film as the Park Avenue home of Daddy Warbucks. A sunburst mask of Apollo, the Greek god of the sun, adorns a segment of the Shadow Lawn ironwork that protects many windows of Wilson Hall.

84

Prof. Lauren K. Woods and his wife, Ellen Terry Woods (both center), each enjoyed small parts in *Annie*.

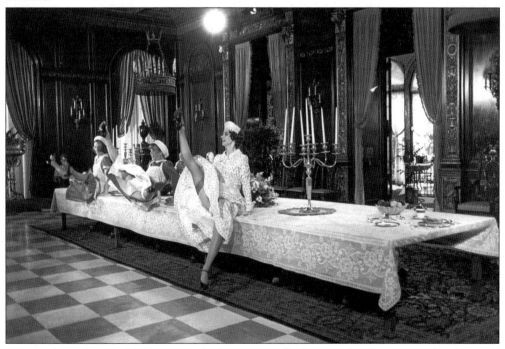

A musical number in the film is caught here in a still photograph. The rooms of Wilson Hall created a fabulous background for the riches Little Orphan Annie would encounter after years at an orphanage and a life of poverty.

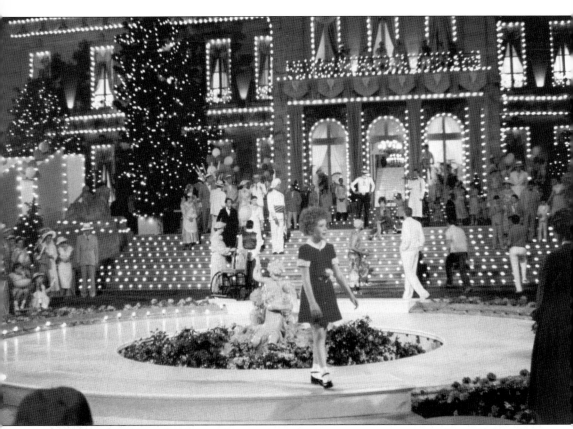

Wilson Hall glitters with thousands of lights during a scene in the movie. Annie is standing on the edge of the fountain.

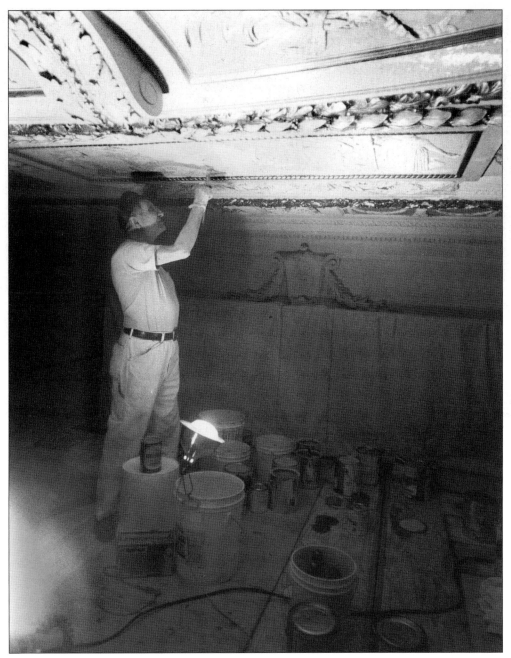

Monmouth College physical plant staffer Russ Melina, a self-taught specialist in decorative arts, re-created a design that because of water damage had been completely painted over in Wilson Hall. He restored the murals, ceilings, and other details by looking at enlarged photographs of the original building, as it appeared in the Parsons' days in Shadow Lawn. Melina, nicknamed "Michelangelo," worked for years on the restoration.

In the 1980s, students in the now defunct equestrian club rode their horses on the Great Lawn.

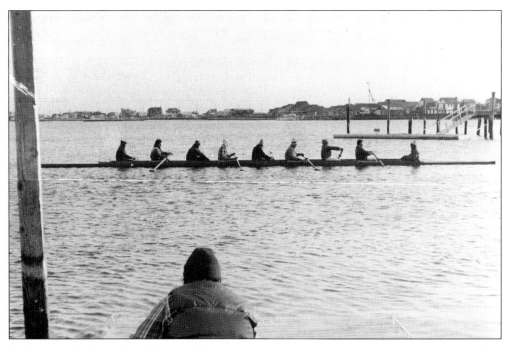

Monmouth College's first "heavyweight eight" rowing team took to the water for their first training session on the Shrewsbury River. The crew was the first in Monmouth's history and, in the 1980s, competed with some of the finest colleges and universities in the East, including Villanova and Drexel.

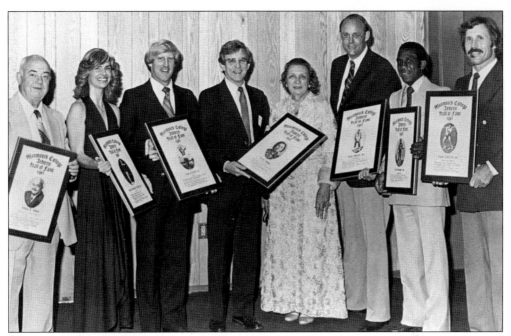

The Monmouth College Athletic Hall of Fame was established in 1987. Pictured, from left to right, are William Boylan, associate professor, director of athletics, and head basketball coach; Susan Steadman LaGlise (Class of 1969), national intercollegiate diving champion of 1967; Kenneth Tillman (Class of 1971), national intercollegiate champion in 10 events; Samuel Magill; Ann R. Nowick, benefactor; Walter Mischler (Class of 1962), Monmouth's first NAIA All-American, 1962; Ron Kornegay (Class of 1969); and August Zilincar III (Class of 1969), NAIA hammer throw champion of 1968.

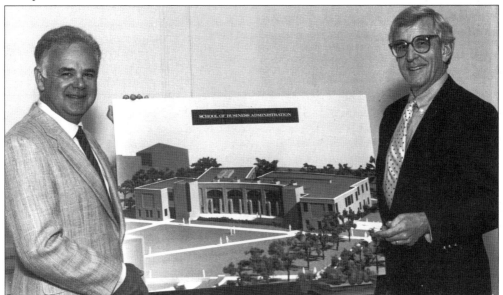

Stanley Bey (left), former chairman of the board of trustees and 1959 Monmouth College alumnus, holds an architect's rendering for the new School of Business Administration with Pres. Samuel Magill. Samuel E. and Mollie Bey Hall was built in the 1980s.

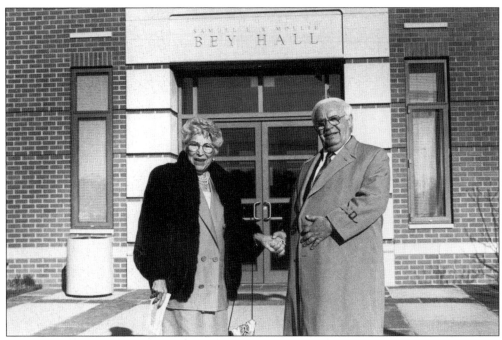

Stanley Bey gave a $1 million gift to have the new school building named for his parents, Samuel and Mollie Bey, who are shown standing at the entrance.

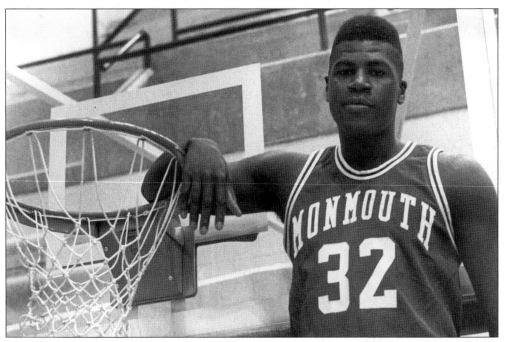

Star basketball player Alex Blackwell went from the Monmouth College Hawks to the Los Angeles Lakers of the National Basketball Association (NBA). Blackwell also played for the U.S. team in the Pan-American Games, for a professional basketball team in Europe, and in the Continental Basketball Association (CBA).

Pres. Samuel Magill (left) and Vice Pres. Richard Kuntz (right) stand with Sen. Bill Bradley, who received an honorary degree from Monmouth College and gave the commencement address in June 1992.

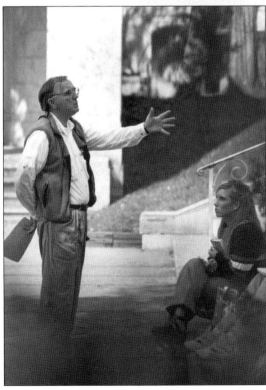

Dr. William P. Mitchell, interim dean of the Wayne D. McMurray School of Humanities and Social Sciences, is a professor of anthropology. He holds the Freed Foundation Endowed Chair in Social Science at the university.

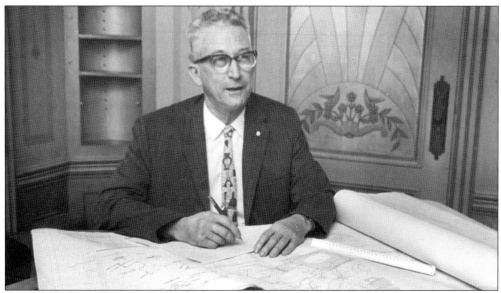

C. Walt Withey—named bursar in 1954, business manager in 1956, and vice president for business affairs in 1966—enjoyed an association with Monmouth University that dated from the 1930s. At that time, he was known to Hubert Templeton Parson for having studied poultry pathology at Rutgers University. Parson engaged Withey to care for a flock of turkeys that developed a life-threatening disease. Withey's duties at Shadow Lawn lasted until 1939, when he took on other jobs. Withey was recognized for his contributions with a chapel in Wilson Hall and the three-story C. Walt Withey building, part of the original Shadow Lawn estate. The Withey building was home to academic offices of the education, sociology, anthropology, social work, and criminal justice departments.

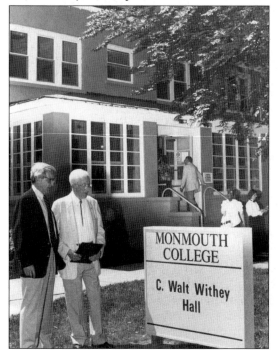

Pres. Samuel Magill and C. Walt Withey admire the sign for the hall. On January 12, 2002, Withy died at the age of 97 in Shelburne, Vermont. Born in New York City, he was married to Mary Withey, who died in 1987. Their son Robert and his wife, Maria, said upon Walt's death, "His keen mind . . . and humorous outlook on life . . . will be missed."

American social critic and author Lewis Mumford's 100th birthday sparked a series of public events and panel discussions in February 1995 at Monmouth University. The university is the repository of Mumford's private library and approximately 300 works of his art, many of which were exhibited at the 800 Gallery on campus. Lewis Mumford has been described as a visionary who foresaw the consequences of the machine on modern man. Born on October 19, 1895, Mumford died in 1990.

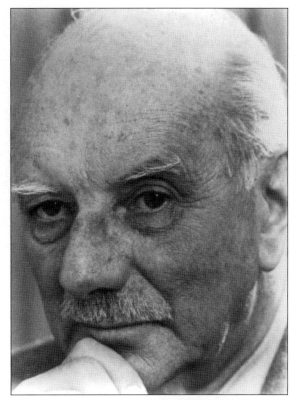

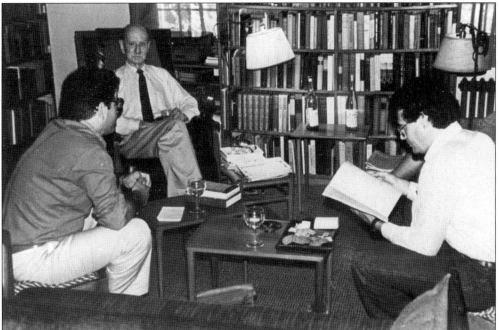

Vincent DiMattio (left), chairman of the art department, and Dr. Donald L. Miller (right), the John Henry MacCracken Professor of History at Lafayette College and author of *Lewis Mumford: A Life*, join Mumford (center) for a chat at the critic's home.

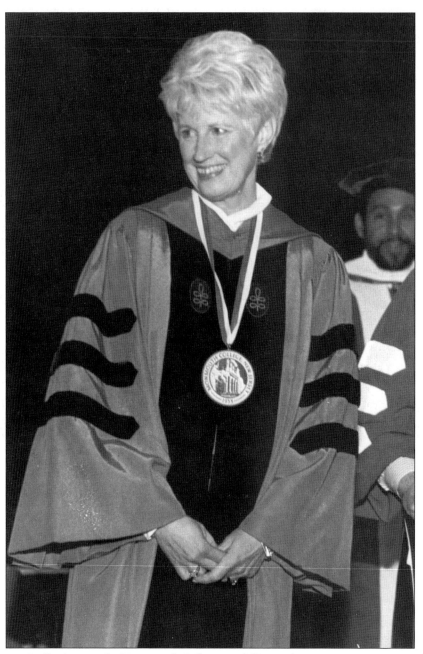

Dr. Rebecca Stafford wears the Monmouth College medallion at her inauguration as president of the college in April 1994. At the beginning of her administration in 1993, Stafford outlined a new vision for Monmouth University 2000. A graduate of Harvard University, she initiated new capital improvement plans and revamped the admission program to increase undergraduate enrollment and raise the academic level of the student body. An enrollment increase of 380 more students in 1995 over the previous year and an increased average SAT score by 46 points of incoming freshmen attested to Stafford's successful endeavors. Also under her administration came new residence halls, the Graduate School, the Schlaefer School, and the School of Education, each with its own faculty.

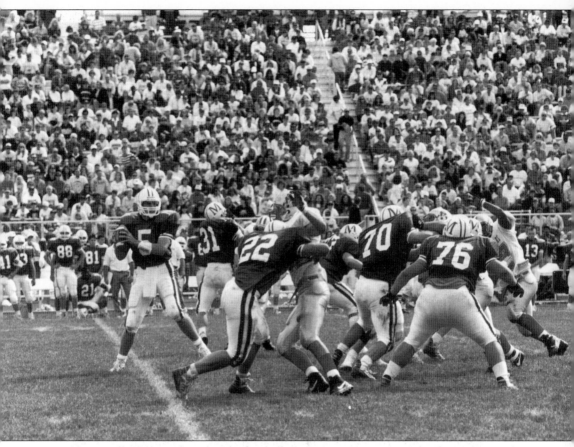

Pres. Rebecca Stafford also ushered in the football program in 1993 at Monmouth University. The Hawks played to a packed Kessler Field from the beginning.

From left to right are Donald Burnaford (Class of 1972), Deborah Burnaford, Henni Kessler (Class of 1968), and John Kessler (Class of 1969). The Kesslers donated funds toward the construction of the football field named in their honor. Both the Kesslers and Burnafords championed the beginning of the Monmouth football program.

Former basketball coach and athletic director Wayne Szoke introduces the new Monmouth football coach, Kevin Callahan (center), who had been the defensive coordinator at Colgate University. On the far right is Callahan's wife, Anne Marie.

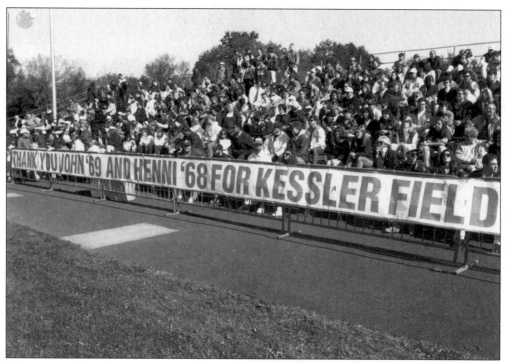

This image offers a long view of the bleachers at Kessler Field in 1993.

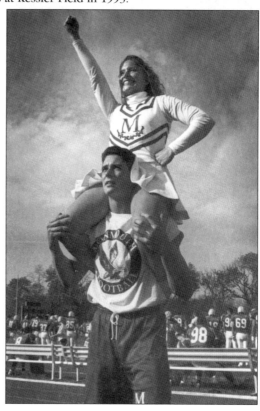

The Hawks are hailed by enthusiastic
cheerleaders in 1995.

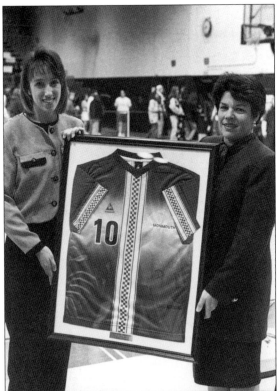

Jeannette Goepfert (Class of 1992), left, was Monmouth University's first Division I All-American athlete in women's soccer. In this picture, her uniform number is being retired. To the right is Dr. Marilyn McNeil, athletic director.

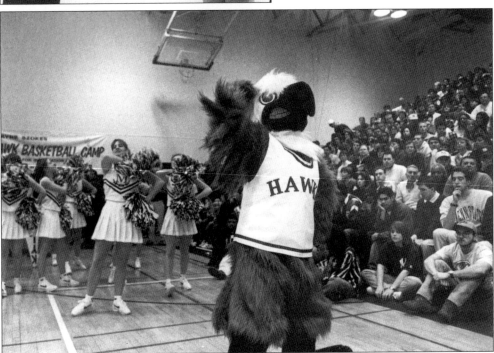

A newer version of the Hawk mascot steps in time with the cheerleading squad at a basketball game in the William H. Boylan Gymnasium.

Five

INTRODUCING
MONMOUTH UNIVERSITY

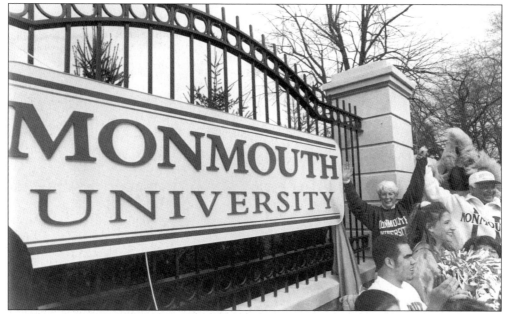

Pres. Rebecca Stafford unveils the new sign of the times on March 24, 1995, at Cedar Avenue on the north campus. At the right is Stanley Bey, chairman of the board of trustees, who was on the state Board of Higher Education that voted on awarding university status to Monmouth. Former president Samuel Magill's initial effort to lobby the state board 10 years earlier finally materialized as Monmouth celebrated University Day.

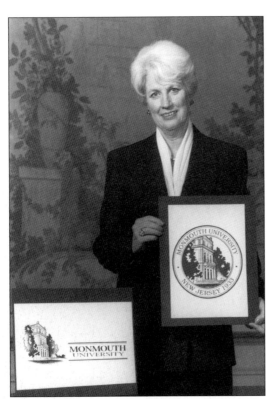

Pres. Rebecca Stafford, standing in front of murals in the president's office, holds the new emblem for Monmouth University.

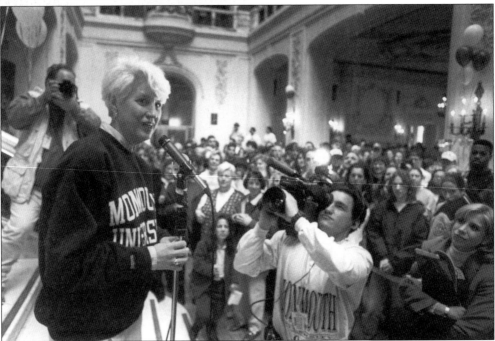

"This is the end of a long dream," Stafford said as Dean Smith, a Monmouth graduate and Monmouth Cablevision cameraman, filmed her. "It's taken 10 years or more. . . . We trust that we will deserve to be one of your finest universities."

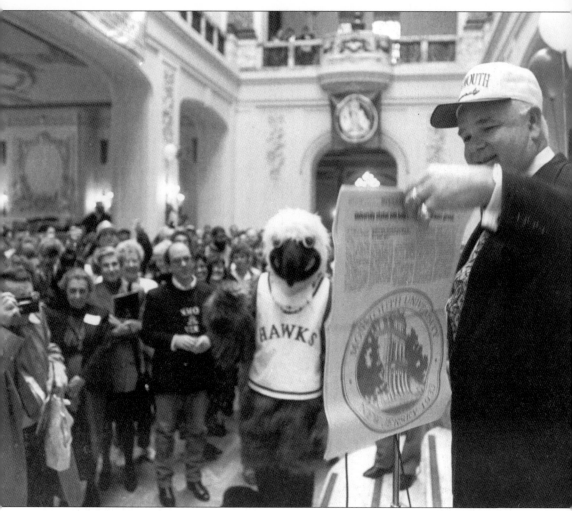

Stanley Bey proudly displays the front page of the *Outlook* on University Day. Thomas Zambrano, then chief of police, said, "It's very exciting to see the energy of the people as we move to university status. As an alumnus and employee, it's very gratifying."

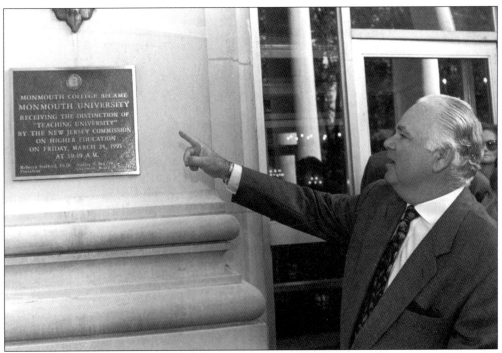

Stanley Bey points to a plaque honoring Monmouth's new distinction as a university. The plaque is located at the entrance of Wilson Hall.

Bey's toast prompted many a comment across the campus, including that of Dean Datta Naik, who had the primary responsibility for preparing the final petition for university status. "It feels great," Naik said. "This is a moment I will remember forever."

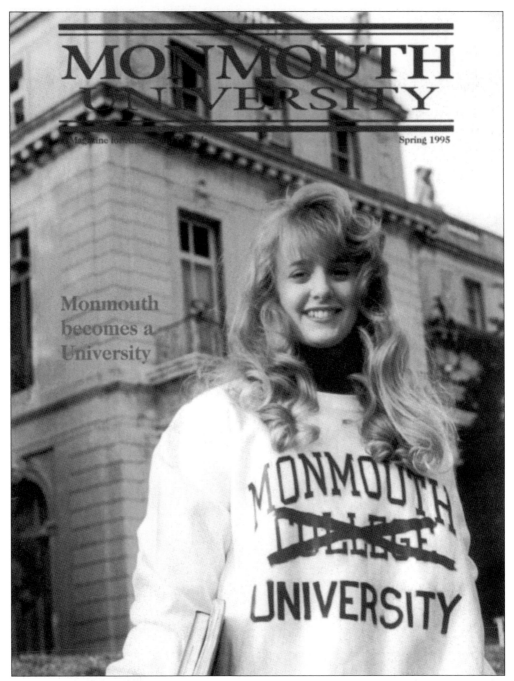

MONMOUTH UNIVERSITY

Magazine for the

Spring 1995

Monmouth becomes a University

MONMOUTH ~~COLLEGE~~ UNIVERSITY

Student government president Mary Kane graces the cover of the spring 1995 edition of the university alumni magazine that details Monmouth's rise to university status. "I've seen many changes take place," she said, "but this is the biggest accomplishment that our institution has achieved since I began here as a student. I take great pleasure in being a student of the *first* graduating class of Monmouth University."

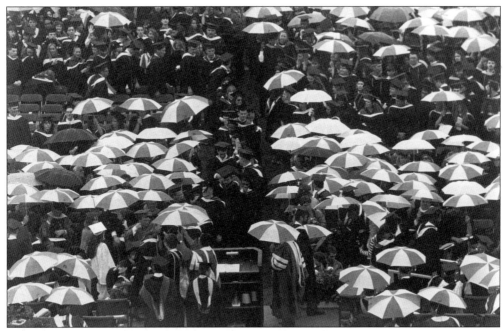

Rain did not dampen the first university commencement. After the new status was granted in 1995, William Hill, then director of placement, said, "The transition from college to university will really put us on the map."

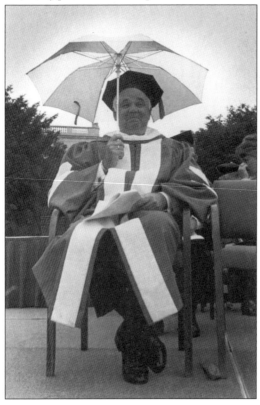

Stanley Bey remains undaunted under an umbrella in the rain, perhaps still reveling in the University Day glory.

Christie Pearce (Class of 1997)
"earned her spot among the best,"
according to the fall 1999
Monmouth University Magazine.
"She has a drive that is extremely
focused to an end." She was a
member of the U.S. Women's World
Cup Soccer team that won the Gold
Medal that summer.

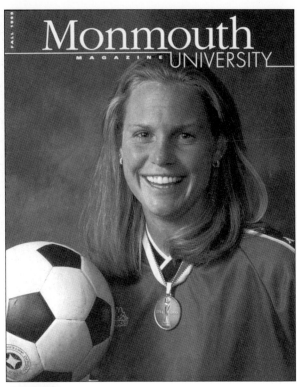

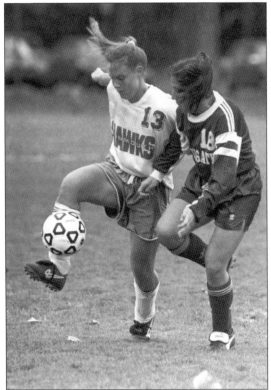

Pearce (left) is seen here on the soccer
field at Monmouth University. She was a
three-time All-Northeast Conference
player and was a member of the U.S.
National Team and the U.S. Olympic
Women's Soccer Team. She now
plays professional soccer for the New
York Power.

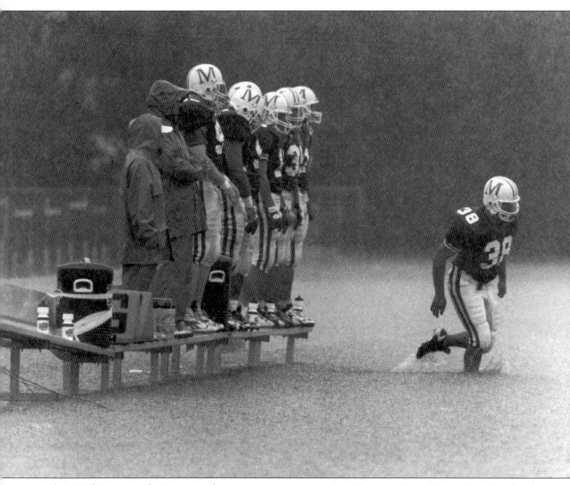

The 1996 Monmouth University homecoming game against Towson State University (Maryland) featured a deluge that left several inches of water covering Kessler Field. Towson splashed its way to a 15-6 win over Monmouth.

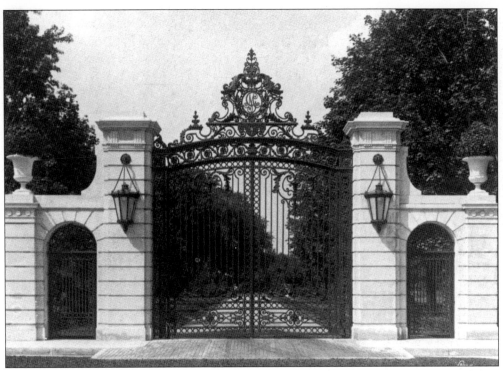

The old Cedar Avenue gateway to the former Monmouth College shows the letter *G* (for Guggenheim) superimposed over an *M* and an *L* (for Murry and Leonie) at its crest.

While retaining the original gate's early-20th-century flavor, the new gate's crest features an *MU*.

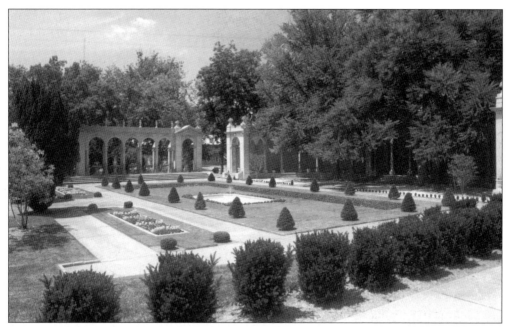

Renowned French landscape architect Achille Duchene designed the formal garden to the west of Wilson Hall. The garden is now known as the Erlanger Memorial Garden, in memory of Charles and Rebecca Erlanger. A colonnade featuring a peristyle teahouse in the center encloses one side of the garden. A water organ fountain, which is modeled on La Colonnade at Versailles, forms the boundary on the west side. In 1997, the university restored the Erlanger Garden, conforming as closely as possible to the original plantings.

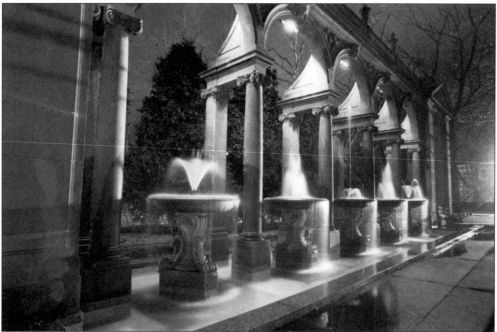

The colonnade and fountains illuminated at night create an atmosphere that renowned Hungarian-Armenian photographer Andre Kertesz would have loved to photograph.

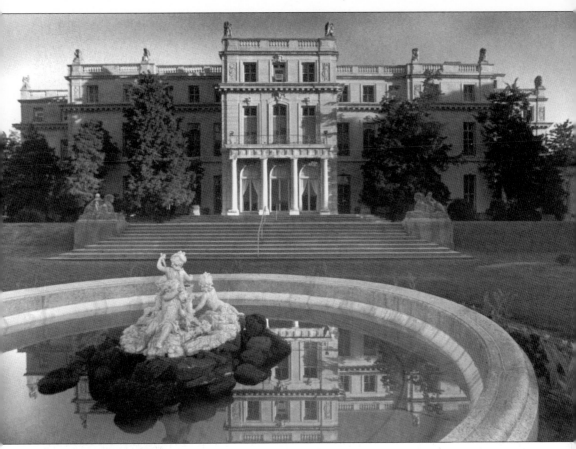

The south facade of Wilson Hall reflected in the fountain creates a stunning image.

Elizabeth Dole, who received an honorary degree in 1998, speaks at the commencement ceremony. She is a graduate of Duke and Harvard Universities and a member of the Washington, D.C. bar. The wife of former senator Robert Dole, she holds many distinctions, including charitable organization administrator, secretary of labor, and secretary of transportation. In 1995, she was inducted into the National Women's Hall of Fame.

America's Poet Laureate Robert Pinsky, a 1958 graduate of Long Branch High School, received an honorary degree in 1997. Pinsky, an alumnus of Rutgers and Stanford Universities, has written 10 books, including 5 books of original poetry. The recipient of Fullbright, National Endowment for the Humanities, and other fellowships, he teaches creative writing at Boston University.

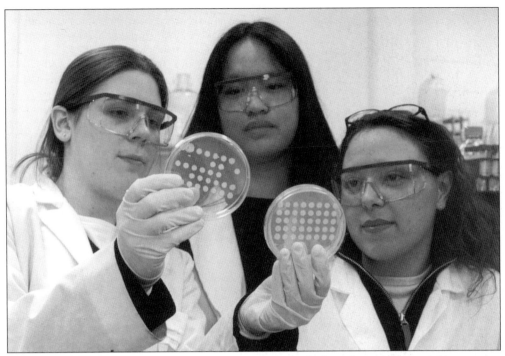

Three science students examine petri dishes used especially for cultures in bacteriology.

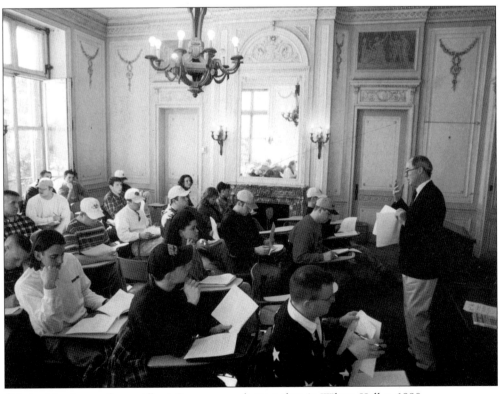

Criminal justice professor Albert Gorman conducts a class in Wilson Hall *c.* 1990.

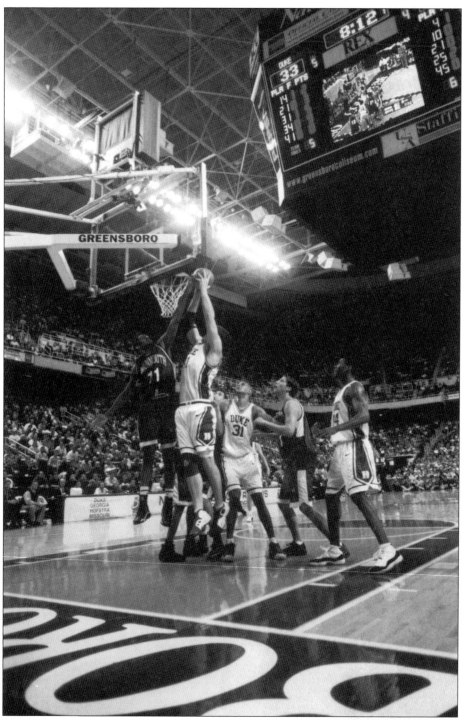

Since moving into NCAA Division I, the Hawks have qualified for two Final Four basketball tournaments. During March Madness 2001, the Hawks played Duke University, the number one–ranked team in the nation and eventual NCAA champions. The game took place in Greensboro Coliseum on prime-time television on the first night of the tournament.

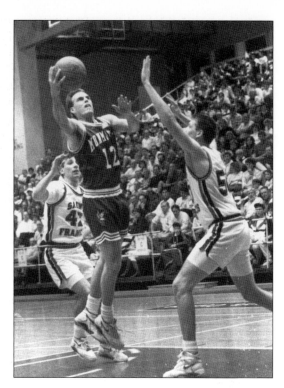

The Hawks were led by coach Dave Calloway (Class of 1992), who wore the No. 12 uniform during his stint as captain of the Monmouth basketball team. Calloway served as an assistant coach for several years before becoming head coach in 1999.

Coach Dean Eahalt's Hawks baseball team qualified for two consecutive NCAA tournaments in 1998, playing the Florida Gators in the first round and, in 1999, playing Texas A & M at College Station, Texas, in the first round. In this view, Eahalt is showered with Gatorade after Monmouth beat Navy to earn a first-round game against the university of Florida.

In the spring of 2001, the Monmouth women's lacrosse team gained their first berth in the NCAA women's lacrosse tournament. Coach Sue Cowperthwait's team was led by Heather Bryan (Class of 2001), who was named the Northeastern Conference (NEC) Player of the Year for the second consecutive season. In the first round, the Hawks played the University of Maryland, six-time national champions and number one–ranked team in the country.

After moving into Division I, the success of the Hawks athletic teams has been due, in part, to the terrific support of the fans.

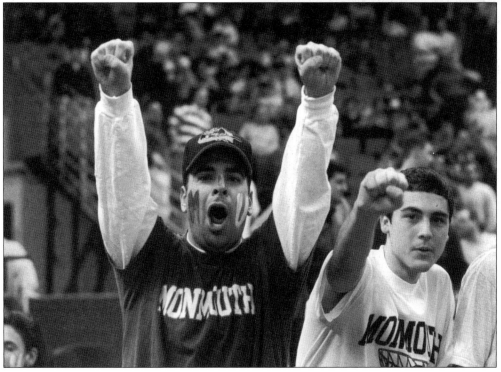

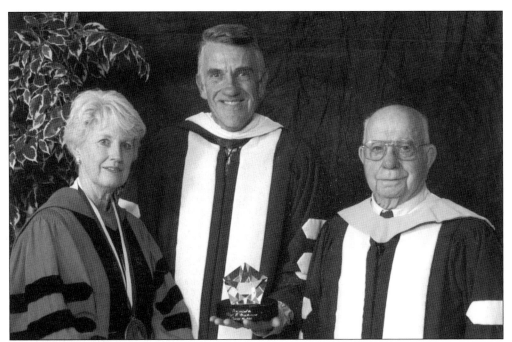

The President's Vision Award, given for outstanding service to the university community, was established at Founder's Day 1999. The first recipient of this prestigious award was life trustee Lloyd F. Christianson (right). Pres. Rebecca Stafford and chairman of the board of trustees Charles Parton presented the award. Christianson, who recieved an honorary degree in 1989, is former CEO of Electronics Associates Inc.

The Marjorie K. Unterberg School of Nursing and Health Studies was established at Monmouth University in 1998. Marjorie Unterberg, a great admirer of nurses, died in 1995, and her family recognized the significance of creating a nursing school in her honor. Pictured here are Mr. and Mrs. Unterburg with Dr. Marilyn M. Lauria (right), now dean and associate professor of nursing.

116

Folksinger Joan Baez performs at Monmouth University in the 1990s. Other visiting performers have included Joel Grey, Gregory Hines, Rita Moreno, Ben Vereen, Dr. John, George Winston, and the Joshua Redman Quartet. The Performing Arts Series encompasses concerts, dance, art, and Broadway legends.

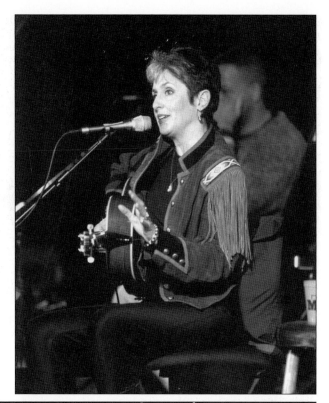

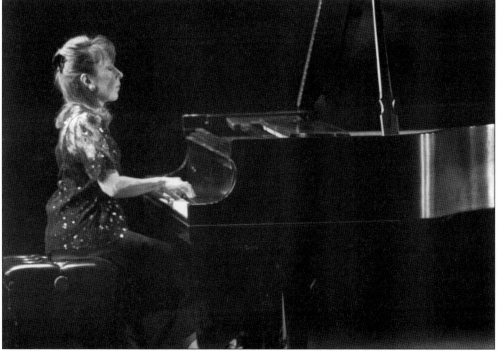

Various groups of entertainers, musicians, and dancers perform onstage at the Pollak Theatre throughout the year. Part of the Performing Arts Series of 1995 included pianist Ruth Laredo.

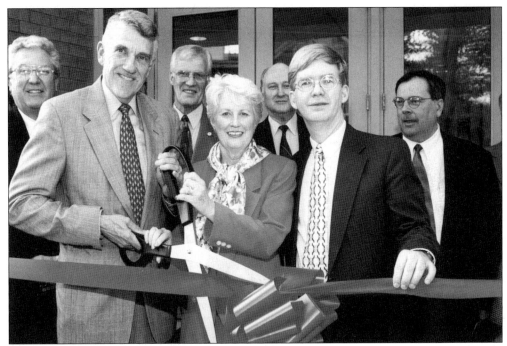

Board of trustees chairman Charles Parton and Pres. Rebecca Stafford cut the ribbon at the opening dedication on May 5, 2000, of the New Academic Building to be renamed in honor of Robert D. McAllan (Class of 1968). In the background are, from left to right, Monmouth County freeholder Edward Stominski; unidentified; Dr. Kenneth Stunkel, of the Wayne D. McMurray School of Humanities and Social Sciences; and Dr. Frank Lutz, dean of the School of Science, Technology and Engineering.

The New Academic Building became McAllan Hall in the spring of 2002.

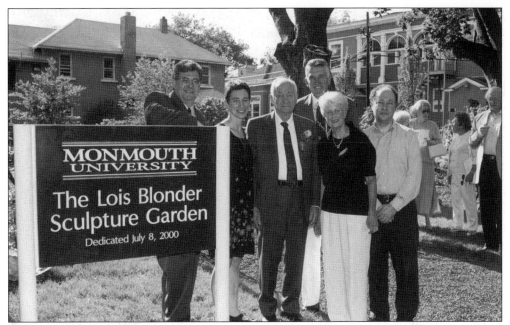

The Lois Blonder Sculpture Garden was donated by Isaac Blonder and his family after Lois's death in 1998. She was an art student at the university and an avid collector of art. The sculpture garden in front of the 800 Gallery and art building is a lovely addition to an already picturesque campus. From left to right are Vince DiMattio, Terry Blonder Golson, Isaac Blonder, Charles Parton, Pres. Rebecca Stafford, and Greg Blonder.

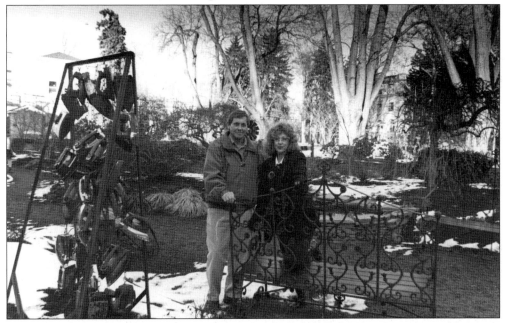

Authors Jim Reme and Tova Navarra pose near a piece entitled *The Iron Curtain,* which stands among sculptures, benches, exotic shrubs and trees, and architectural fragments. The pieces were relocated to Monmouth University by Lois Blonder's family in recognition of her fondness for *objets trouvés.*

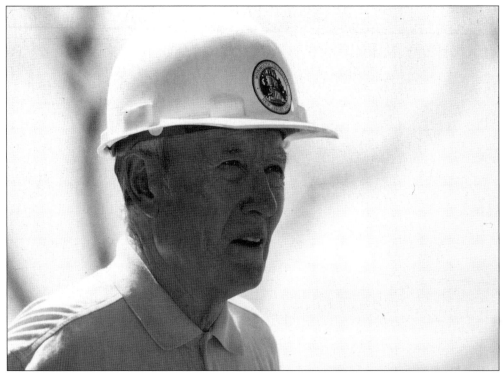

Jules L. Plangere Jr. wears a hard hat on the site of the new Jules L. Plangere Jr. Center for Communication and Instructional Technology (CCIT). Plangere was one of the Asbury Park Press owners who donated the funds for the building, which is being constructed on the site of the former C. Walt Withey Building.

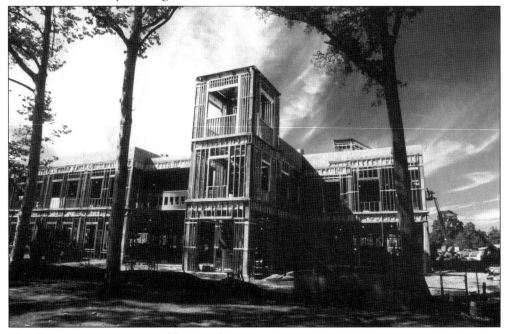

The Plangere Center is pictured here under construction.

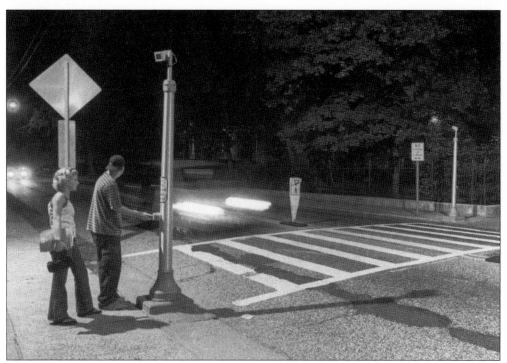

Heavy pedestrian traffic from the north campus to other areas of the university necessitated a crossing guard during most of the school's waking hours. In 2001, the New Jersey State Department of Transportation agreed to alleviate this problem by constructing a pedestrian underpass under Cedar Avenue.

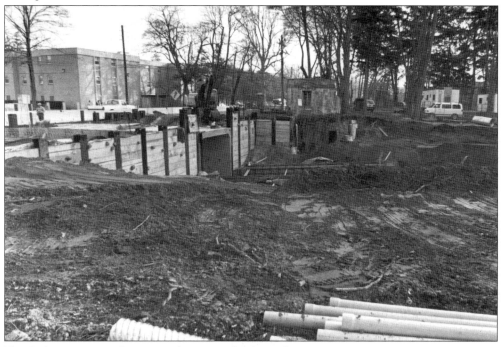

The Cedar Avenue pedestrian underpass is shown under construction.

Above, Ed Banfield (Class of 1936) cranks his truck during the 1963 homecoming celebration. The others are, from left to right, Jay O. Petersen (Class of 1959), Charles W. Ritscher (Class of 1959), and William Apostolacus (Class of 1958). The celebration that year included a basketball game and a parade through the streets of West Long Branch. Fraternities, sororities, and student organizations fashioned the floats. Below is a float from the 1960s. Today, the floats go from the north campus to the Norwood Avenue entrance and circle the campus. Also, the advent of football has provided a more traditional activity for homecoming weekend.

Left: The December 1963 homecoming was postponed from the fall to winter in deference to the assassination of Pres. John F. Kennedy. The title of homecoming queen was shared that year by Mary Ann Hawley (Delta Sigma Pi), left, and Pat Warner (Phi Delta Sigma), right. *Right:* A present-day float shows that enthusiasm for the parade is stronger than ever.

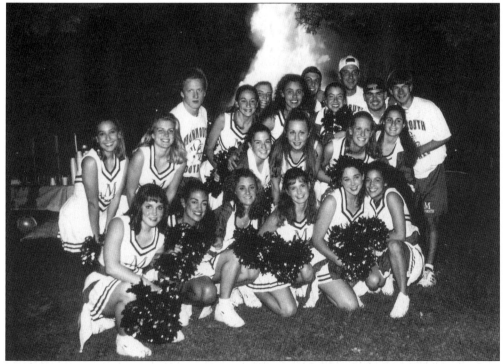

Monmouth University cheerleaders in 1997 pose in front of the annual bonfire, a tradition to kick off homecoming weekend. Today, the bonfire takes place in the quad on the north campus.

A memorial Mass held in the pit area of the student center honored the victims of the September 11, 2001 terrorist attack on the World Trade Center. Keith McHeffey—whose mother, Sherry (Class of 1970), works in the Life and Career Advising Center (LCAC) of Monmouth University—was killed in the attack.

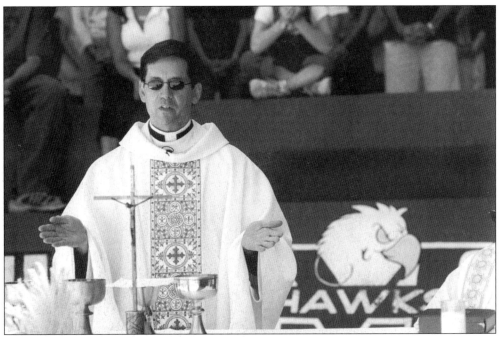

Fr. Michael Lankford, one of the celebrants of the Mass, is chaplain and director of the Catholic Center of Monmouth University.

Kevin Banks, dean of students, stands
among the crowd at the candlelight service.

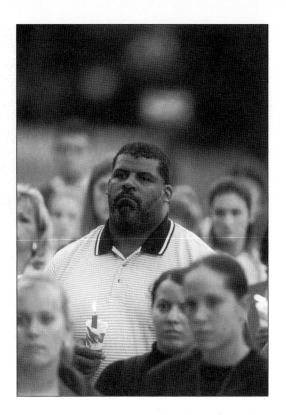

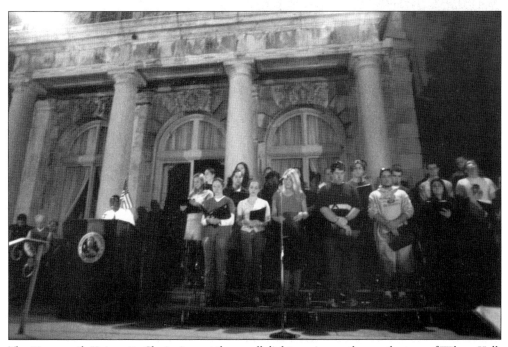

The Monmouth University Choir sings at the candlelight service on the south steps of Wilson Hall.

Dr. Saliba Sarsar, associate vice president for academic program initiatives, leads a panel discussion on the tragic events of September 11, 2001.

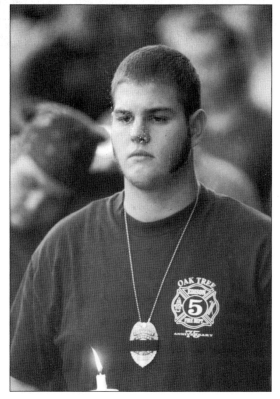

During the service, a young man wears an emergency medical technician's medallion with a black ribbon, a symbol of mourning.

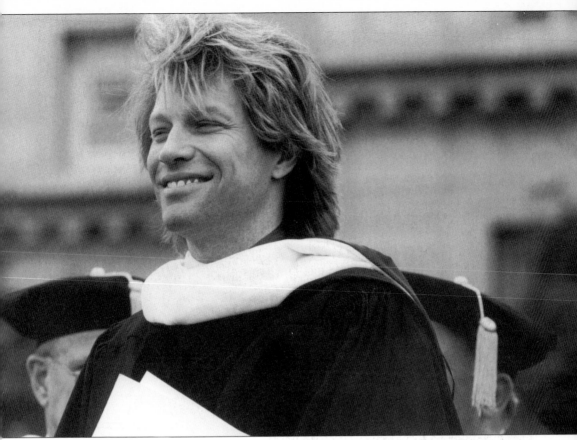

Rock star Jon Bon Jovi accepted an honorary doctorate and gave the graduation address at the Monmouth University commencement ceremony on May 16, 2001. In his speech, he said to nearly 1,300 graduates, "Bon Jovi was not supposed to succeed. Ask any critic. We weren't from New York. We weren't from LA. I didn't live the cliché rock 'n' roll lifestyle that 'legends' were made of. We tried to keep up with the Joneses until I realized that even if you win the rat race, you're still a rat. One out of every 1,000 bands gets a record deal. One out of a million has any success. I've been to the top and I've been written off more than once, but I'm still here. Still the underdog? Maybe. Passionate? Definitely. Nothing is as important as passion. No matter what you want to do with your life, be passionate."

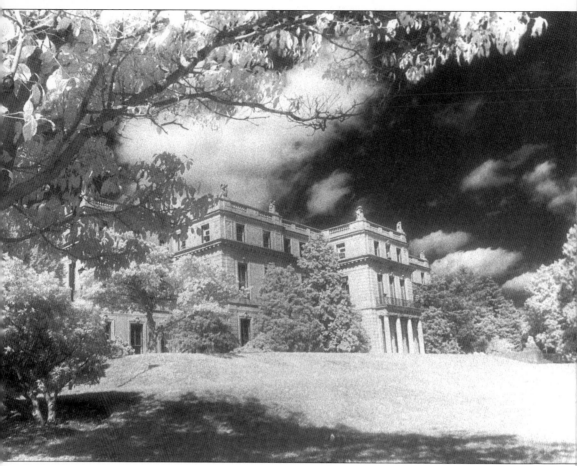

Visitors to the former Shadow Lawn and now historic Woodrow Wilson Hall use a brochure for self-guided tours or make reservations to attend the university's annual candlelight tour, conducted for years by Prof. Arie van Everdingen. The professor includes a slide presentation of the mansion as it was furnished in the 1920s. Previously entered in the National Register of Historic Places, Wilson Hall was designated a National Historic Landmark in 1985 by the Department of the Interior. The mansion serves as the administrative center of the university, and some classes are held there as well. As part of Monmouth University's 50th anniversary in 1984, the McMurray-Bennett Foundation, the National Endowment for the Humanities, the State of New Jersey, and private contributors provided $770,000 for an extensive restoration project. The Ionic columns with pendant festoons well represent the mansion's 130 rooms on three main floors, plus rooftop and lower-level rooms. In the main portion, there are 96 rooms, including 17 master suites and 19 baths. Monmouth University is committed to an ongoing restoration of this historic site. One of the latest developments is a gift that was bestowed for the restoration of the four-manual, Aeolian-Skinner pipe organ.

However beautiful the campus, the institution's mission is "to promote creativity, intellectual inquiry, research and scholarship as integral components of the teaching and learning process. . . . Monmouth University enables undergraduate and graduate students to pursue their educational goals, determine the direction of their lives, and contribute significantly to their profession, community, and society."